DECOLONIZING REFINEMENT

Contemporary Pursuits in the Art of Edouard Duval-Carrié

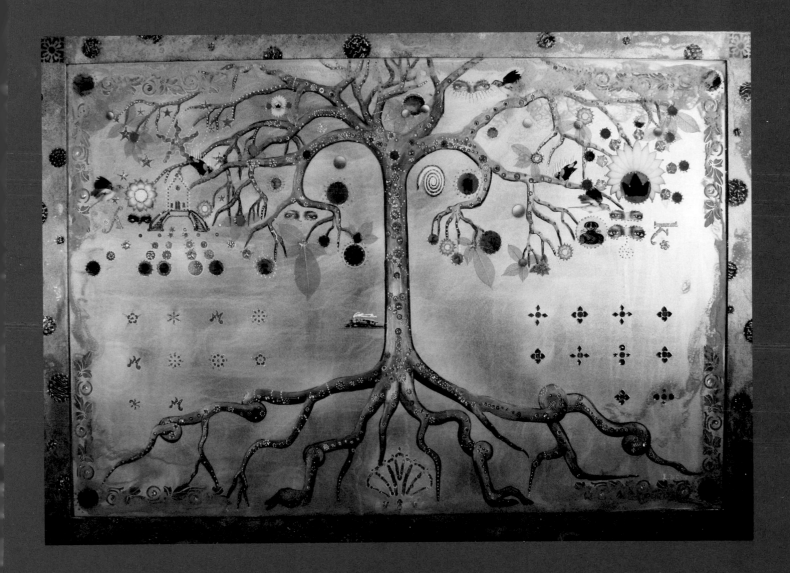

EXHIBITION CURATORS
Paul B. Niell | Michael D. Carrasco | Lesley A. Wolff

ESSAYS BY THE CURATORS &
Anthony Bogues | Martin Munro | Edward J. Sullivan

FEBRUARY 16 — APRIL 1, 2018
Florida State University Museum of Fine Arts

Exhibition Organization

The exhibition Decolonizing Refinement: Contemporary Pursuits in the Art of Edouard Duval-Carrié was organized by the Florida State University Museum of Fine Arts in concert with Professor Paul Niell of the Department of Art History. Project Staff: Allys Palladino-Craig, Editor and Grant Writer; Jean D. Young, Registrar and Book Designer; Viki D. Thompson Wylder, Curator of Education; Wayne T. Vonada, Jr., Exhibitions Preparator and Designer; Elizabeth McLendon, Archivist and Communications Coordinator; Rachel Collins, College of Fine Arts Chief Operations Manager.

Sponsorship

The catalogue of the exhibition has been underwritten by the award of an Arts & Humanities Program Enhancement Grant from Florida State University to Professor Paul B. Niell.

This program, February 16-April 1, 2018, is sponsored in part by an award from the City of Tallahassee and Leon County administered by the Council on Culture & Arts; Opening Nights; and by a grant from the State of Florida, Division of Cultural Affairs.

The Museum of Fine Arts Press

Allys Palladino-Craig, Editor-in-Chief
Jean D. Young, Book Designer
Printer: Gandy Printers, Tallahassee, FL

Table of Contents

◄Edouard Duval-Carrié, detail of *Sugar Conventions*, 2013, mixed media on backlit Plexiglas, 72 x 72 inches. Courtesy of the Winthrop-King Institute for Contemporary French and Francophone Studies, Florida State University, Tallahassee, Florida.

Acknowledgments

Benefactors and Lenders to the Exhibition

The Nell Bryant Kibler Memorial Endowment • Dr. Kenneth Reckford and Charlotte Orth Reckford • Goodwood Museum & Gardens, Tallahassee • Special Collections and Archives, Florida State University Libraries • Lyle O. Reitzel Gallery, New York—Santo Domingo • Museum of Contemporary Art, North Miami • Thomas County Historical Society, Georgia • The Florida Division of Historical Resources • Southeastern Archaeological Center, Tallahassee

We would like to thank Edouard Duval-Carrié for collaborating with us, including our November 2015 trip to his studio in Miami and the extensive visit he made to Tallahassee for research in January 2017. Throughout this process, Edouard's enthusiasm for this collaboration as a multi-faceted educational endeavor has been an inspiration to all of us involved. We thank Scott Shamp, Interim Dean of the College of Fine Arts at Florida State University for his support and in the Dean's office, we also thank Rachel Collins, Jessica Comas, Bobbie Fernandez, and Gabrielle Taylor.

Our authors, whose commentary has expanded the scholarly horizons of this project, are gratefully acknowledged: Anthony Bogues, Director of the Center for the Study of Slavery & Justice at Brown University; Edward J. Sullivan, Institute of Fine Arts and the Department of Art History, New York University; and Martin Munro, Director of the Winthrop-King Institute for Contemporary French and Francophone Studies at Florida State University.

In the Department of Art at Florida State University, we would like to acknowledge those who have helped us to develop a student collaboration with Edouard. Faculty and staff who have worked on the student exhibition at CAB Open Gallery that will be juried by Edouard Duval-Carrié are: Lilian Garcia-Roig, Janae Easton, and Liz DiDonna; Harris Wiltshire, Associate Professor in the Visual Arts at Florida A & M University, is coordinating FAMU student works; and Mark Messersmith, FSU Art Professor with students Sharon Norwood and Brian Holcombe are part of the exhibition project. Also in the Department of Art, we are indebted to former Chair, Carolyn Henne, and to Facility for Arts Research administrator Judy Rushin, and to Noah Z. Brock, for helping Edouard to realize *The Kingdom of This World* laser engravings.

In the Department of Art History, we thank Adam Jolles, Chair of the department, and Jean Hudson and Sheri Patton for their technical assistance on many fronts. In the Department of Modern Languages and Linguistics, it is a privilege to acknowledge our colleague Martin Munro, Director of the Winthrop-King Institute for Contemporary French and Francophone Studies at Florida State University.

We thank all benefactors and lenders to the exhibition, including the Nell Bryant Kibler Memorial Endowment of Florida State University Museum of Fine Arts. In support of this exhibition catalogue, we are grateful to the Council on Research and Creativity at Florida State University. The Division of Cultural Affairs for the State of Florida evaluates grant proposals annually, and funding for meritorious programming from the DCA is deeply appreciated along with funding from the City of Tallahassee and Leon County that is administered by the Council on Culture & Arts. Of this latter organization, we would like to acknowledge the promotional assistance of Audra Pittman and Erica Thaler.

We wish to express our deepest gratitude to the following individuals and collections for working with us to make their materials accessible and in some cases, available for the exhibition. These include Katie McCormick of the Special Collections and Archives, Florida State University Libraries; Daniela Paiewonsky, Maria Monegro, Mar Martínez, and Lyle Reitzel of the Lyle O. Reitzel Gallery in New York City; Jonelle Demby at the Museum of Contemporary Art, North Miami; Anne McCudden and Ephraim J. Rotter at the Thomas County Historical Society & Museum of History in Thomasville, Georgia; Marie Prentice, Steve Karacic, Jerry Lee, Mary Glowacki, and Dan Seinfeld at the Bureau of Archaeological Research at Mission San Luis in Tallahassee, Florida Department of State, Division of Historical Resources; David Morgan and Richard Vernon at the Southeastern Archaeological Center of the National Park Service in Tallahassee; Nancy Morgan and Jennifer Humayun of Goodwood Museum & Gardens in Tallahassee; and Mary Fernandez of The Grove Museum also in Tallahassee.

Students in the Department of Art History who have generously lent their time to the promotional and educational dimensions of this show include Alexis Assam, Phyllis Asztalos, Sumaya Ayad, Taylor Crosby, Morgan Gunther, Rachel Fesperman, Ashton Langrick, Ashley Lindeman, Sarah Shivers, and Emily Thames.

—Paul B. Niell, Co-Curators & Museum of Fine Arts

◀Edouard Duval-Carrié, detail of *Purple Lace Tree*, 2013, mixed media on aluminum in artist's frame, 71 x 86 inches. Lyle O. Reitzel Gallery New York—Santo Domingo.

Preface: A Note on Decolonizing

Paul B. Niell

"By 'colonial differences' I mean, through my argument . . . the classification of the planet in the modern / colonial imaginary, by enacting coloniality of power, an energy and a machinery to transform differences into values."
—Walter D. Mignolo, *Local Histories / Global Designs* (2000)[1]

To "decolonize" is a verb, an action, and in the contemporary milieu of modern nation states seeking to express their status as independent republics, it can seem out of place as a term. Isn't the colonial period behind us, one might ask? Surely the late eighteenth- and early nineteenth-century Age of Independence began a process of dismantling parasitic colonial administrations, sucking the life and resources from once pristine environments where people were either dispossessed of their lands or carried from far away to labor in a land of diaspora. That imperial and colonial historical process ended, did it not, in 1947, when the remainder of colonial administrations finally gave way after World War II? Yet, when we invoke "colonialism" and talk about Colonial Studies today, we are not addressing a logic and a practice only relegated to the past. How should we, for example, contextualize various contemporary events, situations, and conditions that would seem to reflect colonial patterns? Puerto Rico's spiraling debt crisis, an island tethered to the United States and entangled by the Jones Act as seen in the emergency efforts after the hurricanes of September 2017, exists in a political designation that is officially denominated as "US territory" or "commonwealth." What should we make of the cries of protest in Guam, another US territory, from its residents and indigenous people who have found themselves positioned in the crosshairs of edgy governments?

One response to these questions is that we need to appreciate that an argument can convincingly be made that the practice of colonialism in some form is alive and well. There are many cases globally. Taiwan and Ukraine could be said to exist in contemporary colonial predicaments. If we think that the project of world empire has been extinguished, then what are we to make of Great Britain's "Commonwealth of Nations," an alliance of 52 member

1 Walter D. Mignolo, *Local Histories / Global Designs: Coloniality, Subaltern Knowledges, and Border Thinking* (Princeton, NJ: Princeton University Press, 2000), 13. See also *Coloniality at Large: Latin America and the Postcolonial Debate,* edited by Mabel Moraña, Enrique Dussel, and Carlos A. Jáuregui (Durham, NC and London: Duke University Press, 2008) and Walter D. Mignolo, *The Darker Side of Western Modernity: Global Futures, Decolonial Options* (Durham, NC, and London: Duke University Press, 2011).

states including Australia, New Guinea, New Zealand, Belize, Canada, Anguilla, Grenada, and other "decolonized countries" that are not technically republics nor their own monarchies? At the very least, the entire conception of the Commonwealth comprises countries tied to Britain socially and culturally because they formerly constituted a political body of the British empire and perhaps because such an arrangement still affords Britain certain global advantages. The words "colonial" and "empire" are not politically correct today; they have passed from modern political usage as they signify antiquated forms of coercive and domineering government by the Western metropolis that modern society wishes to move on from. However, to "decolonize" in the view of my co-curators and myself as in the view of decolonial theorists such as Walter D. Mignolo, quoted above, is not necessarily to end colonial administrations, to break up empires, or to cease our concerns once such governments crash as they finally did officially in 1947, or so. Instead, we refer to the critiquing, the conceptual undoing, and the exposure of a system of thought and practice that has transcended actual colonial administrations and that still operates as, according to Mignolo, "an energy and a machinery to transform differences into values."

The world that Christopher Columbus captured in random glimpses through the journal he kept on his four transatlantic voyages and that subsequent chroniclers would describe in text and image, that which Columbus opened up to European invasion and exploitation, was filled with myriad "differences" for the late fifteenth-century European observer. Its human occupants were described by Columbus in his journal upon first seeing them in October of 1492. He wrote to the Catholic monarchs of Spain, Isabella I and Ferdinand II regarding these indigenous people, "They should be good servants and of quick intelligence, since I see that they very soon say all that is said to them, and I believe that they would easily be made Christians, for it appeared to me that they have no creed. Our Lord willing, at the time of my departure I will bring back six of them to your Highnesses, that they may learn to talk."[2] That Columbus seems to have automatically seen labor and servitude in the peoples of a foreign land that would eventually be named the New World and the Americas has been explained in various ways. These people had no written language, wore less clothing than Europeans, and seemed to have little shame regarding nudity. They spoke in a different tongue, practiced a non-Christian religion, and famously did not, in Columbus' view, understand the [European] value of gold. They were different, to be sure, and this encounter between formerly alien cultures is viewed by historians as one of the most dramatically abrupt in world history. These people could be taken up as labor in Europe's expanding markets, but from the rest of Columbus' remarks, it is clear that they would not rise from this subordinate position without major conflict. Columbus' response exposes the early development of a European filter for converting the differences of these indigenous people and eventually many others into

2 Christopher Columbus and Cecil Jane trans. *The Journal of Christopher Columbus* (New York, NY: Clarkson N. Potter, 1960), 24.

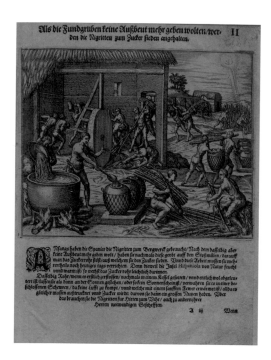

a European sense of values. Differences quickly became a question of "otherness" and this European "othering" of indigenous peoples would continue through the production of text, image, and practice over the next few centuries. In fact, in the early modern period following 1492, Europeans would reduce the indigenous people of the Americas to a category of "Indian," based on Columbus' ignorance that Asia, "the east Indies," was not right in front of him but a continent and another ocean away. The German printer, Theodor de Bry (1528-1598), drawing from the account of Girolamo Benzoni (1519-ca. 1570), rendered Europeans exacting labor from Amerindians and / or Africans in his late sixteenth-century *Der ander Theyl, der newlich erfundenen Landtschafft Americae* in which such laborers are depicted through stereotyped stock figures that betray de Bry's commerce with the European market in images and ideas rather than his first-hand experience.[3] De Bry never traveled to America. Still, his printed images framed what his viewers might expect to see there, including things wildly exaggerated like his depictions of cannibalism, or things more probable in the scenes of Europeans forcing Amerindian and African laborers to refine sugar cane through a process of cutting, crushing, and boiling it down. More analytical images of sugar refinement followed, such as those of the seventeenth-century encyclopedic book by the German polymath Erasmus Francisci.[4]

▲Engraving of sugar cane cutting and refining from Theodor de Bry, *Der ander Theyl, der newlich erfundenen Landtschafft Americae*, 1591. Rare Books Collection, Special Collections and Archives, Florida State University, Tallahassee, Florida.

Text from engraving: *After the mines were exhausted / the* Nigritten *(Africans?) were coerced to boil sugar*

In the beginning the Spanish used Africans for mining; after these repositories were fully exploited, they were used to grind sugar cane from which sugar is boiled. This labor is still performed today. Sugar cane grows easily on Hispaniola because the island is damp and warm…The above-mentioned cane is first crushed, then boiled in a kettle…then it is stood in the sun to dry. When the weather is inclement, the cane is stored in a locked and airtight barn warmed by a gentle fire. This procedure is for drying out the cane evenly; at this point, it becomes the sugar for which the Spanish have great use. Besides this, the Spanish use Africans as shepherds for their livestock, in addition to having them perform other necessary business for their masters. [*Abridged translation provided by Stephanie Leitch*]

To use the expression "Indian" today is not to bring back the colonial administrations and historical actors that exacted labor from indigenous peoples, stole their lands, and terrorized their families. It is not necessarily to consciously re-credit the European and American intellectuals that through verbal enunciation, text, and image codified the new historical social identities of Indians, blacks, and other racially mixed categories.[5] These homogenizing terms were aimed at creating and controlling labor, making the colonial realm a marginal space to the European center, establishing social hierarchies within colonial societies, and maintaining the normative social relations of the early modern world. Such an invocation of "Indian" or "black" today is, rather, to reinscribe the "coloniality of power," a concept of Aníbal Quijano, that refers to the darker side of modernity, the mechanism by which racism and patriarchy became fundamental to the rise of the capitalist world system.[6] Contemporary examples abound of how these structures

3 Theodor de Bry, *Der ander Theyl, der newlich erfundenen Landschaft Americae, von dreyen Schiffahrten, so die Frantzosen in Floridam . . .* (Franckfurt am Mayn: Getruckt bey J. Feyerabendt, in Verlegung D. von Bry, 1591). Special Collections and Archives, Florida State University Libraries.

4 Erasmus Francisci, *Ost- und west-indischer wie auch sinesischer lust- und stats-garten* (Nürnberg in Verlegung: J.A. Endters / und Wolfgang dess jüngern sel. erben, 1668), 268-269. Special Collections and Archives, Florida State University Libraries.

5 For the role of visual culture in colonialism and the production of empire, see *Empires of Vision: A Reader*, edited by Martin Jay and Sumathi Ramaswamy (Durham, NC, and London: Duke University Press, 2014). For the role of print, text, and mapping in the making of empire and colonial differences, see Walter D. Mignolo, *The Darker Side of the Renaissance: Literacy, Territoriality, and Colonization* (Ann Arbor, MI: The University of Michigan Press, 1995) and José Rabasa, *Inventing America: Spanish Historiography and the Formation of Eurocentrism* (Norman, OK: University of Oklahoma Press, 1994).

6 For a discussion of the coloniality of power, see Aníbal Quijano and Michael Ennis, "Coloniality of Power, Eurocentrism, and Latin America," *Nepantla: Views from South*, Vol. 1, Issue 3, 2000, pp. 533-580.

have persisted. How do peaceful Native American protesters at Standing Rock Reservation in the Dakotas, for example, come to be tear-gassed, fire-hosed, and shot with rubber bullets while standing up against an oil pipeline on their native soil, as armed Neo-Nazis march undisturbed by police into an American college town to promote white supremacy and thereby to sow division and hatred? Why must the notion that African American lives matter become a platform for activism in the wake of indictments of racial profiling by US police departments? To decolonize is, in part, to question the deeper historical developments that account for such contemporary events from the perspectives of the oppressed and to acknowledge that even though colonial administrations have technically ceased operations around much of the world, the logic of coloniality that underlies modernity's rhetoric of progress continues. Our global system relies upon the macro-conversion of differences into values, which originated with such gestures as Columbus' letters to the monarchs of Spain. In other words, patterns of thought, action, and sociability laid down in the so-called "Colonial period," or the "Age of Empire" continue to inform our world today.[7]

The production, refinement, and marketing of sugar on plantations worked by enslaved people became central to the global world economy established by Europeans, as early as the seventeenth century. First introduced by Columbus, sugar cane production and processing flourished initially in the Caribbean before it was largely abandoned in Spanish colonies as an export enterprise in the sixteenth century with the discovery of gold and silver deposits on the mainland. The colonies in Suriname and Brazil in the seventeenth century and Ste. Domingue (modern Haiti) and Jamaica in the eighteenth century dominated sugar production, globally. Spain re-entered the enterprise of plantation agriculture and sugar in the early nineteenth century in Cuba and Puerto Rico in response to the eighteenth-century sugar revolution in the Atlantic world and after the slave insurrection in Ste. Domingue that ruined French dominance in the world sugar market and resulted in the independent nation of Haiti by 1804. Anthropologist Sidney Mintz in his seminal work, *Sweetness and Power: The Place of Sugar in Modern History* (1986), has emphasized the centrality of sugar in the rise of the Industrial Revolution noting, among other things, the caloric boost that it gave to Western societies and industrial workers.[8]

7 Decolonial theorists refer to the "modern / colonial" world to make the argument that, in their view, modernity represents a rhetoric of persuasion that hides the logic of coloniality beneath it. In this sense, modernity and coloniality are two sides of the same coin. See Mignolo, *Local Histories / Global Designs*, 3-45, Moraña, Dussel, and Jáuregui, *Coloniality at Large*, 1-22 and Mignolo, *The Darker Side of Western Modernity*, 1-24.

8 Sidney Mintz, *Sweetness and Power: The Place of Sugar in Modern History* (New York: Penguin Books, 1986). For a social history of the architecture of Jamaica during the British Colonial period (1655-1838) with attention to sugar production, see Louis P. Nelson, *Jamaican Architecture and Empire* (New Haven, CT, and London: Yale University Press, 2016).

▲ Erasmus Francisci, image of sugar re-finement, *Ost- und west-indischer wie auch sinesischer lust- und stats-garten*, 1668. Rare Books Collection, Special Collections and Archives, Florida State University, Tallahassee, Florida.

The plantation system of the Atlantic world produced sugar as it did coffee, tobacco, cotton, indigo, rice, and other commodities for the global world market. Prior to the emancipatory movements of the nineteenth century, these plantations were mostly worked by enslaved people, many from Africa or of African descent. The coloniality of the world system reinforced this arrangement by constructing the notion of "the black," an individual of an automatically lower social station presumed to be intellectually and morally deficient. Atlantic racism homogenized the identities of Africans, positioned them in a subaltern space, and valorized their enslavement and that of their descendants in the plantation system.[9] In the large-scale, export-oriented plantation economies of Brazil, Ste. Domingue, Jamaica, Barbados, and later Cuba and Puerto Rico, the fruit of enslaved labor was often raw material (cotton, sugar, etc.) that could be shipped elsewhere to be processed into finished goods. Global capitalism arose on such labor, and in Tallahassee, we have an important artefactual remnant of our region's investment in this process in Goodwood Plantation. Once a property of around 1,600 acres stretching from today's Betton Hills to Lake Lafayette and constructed in the 1830s soon after Florida became a territory of the United States, Goodwood was built, occupied, and worked by enslaved people. Its ownership prior to the Civil War in the Crooms family, Henrietta Smith, and the Hopkinses, practiced the enslavement of people to profit from a system that by the nineteenth century was over three hundred years old in the Americas. Today we have only photographs of the Goodwood main house façade prior to the early twentieth-century remodeling by Fanny Tiers. In a view from the 1890s, a man of African descent poses with one foot on the central stairs and his head turned right towards the photographer. We see a cast-iron porch and something of the faux-marble surface below and classical detailing above that boasted the refinement of the plantation's principal occupants.

To decolonize refinement, to us, is to critique the role of visual and material culture in the constitution of the coloniality of power from 1492 to the present from the myriad perspectives of the marginalized. Through this collaboration with Edouard Duval-Carrié, we have come to know an artist who grapples with the coloniality of art and its historiography. By his critically acclaimed body of work, Edouard has committed himself to opening up spaces of contemplation, critical reflection, and paradox, where the images and objects of empire sometimes become the very agents employed to challenge and unsettle the conventions that shape the way we see the world.

—*Paul B. Niell*

▶[facing page] Goodwood Plantation, façade, *ca.* 1890s, photograph. Courtesy of Goodwood Museum and Gardens, Tallahassee, Florida.

9 After the abolition of slavery in the Atlantic world, unfair labor practices based on race continued such as sharecropping in the United States southeast.

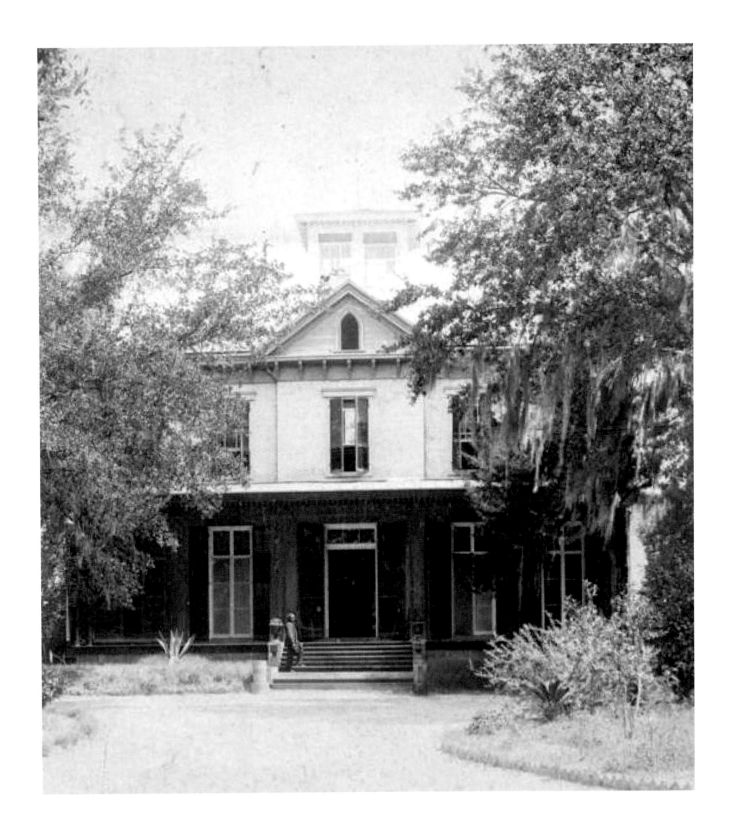

Rituals of Refinement: Edouard Duval-Carrié's Historical Pursuits

Lesley A. Wolff
Michael D. Carrasco
Paul B. Niell

Colonial America may seem far removed from the contemporary fabric of daily life in Tallahassee. However, remnants of Tallahassee's colonial past persist in quiet corners of the city, tucked away behind modern avenues, academic institutions, and bodies of governance. One mile west of Florida State University's campus resides the Spanish Franciscan mission San Luis de Apalachee, built in 1633 at the location of the Apalachee capital of Anhaica. Here, Spanish missionaries compelled the Apalachee natives to produce corn for transport to feed the Spanish settlers along the Atlantic coast. To the east, Spanish explorer Hernando de Soto's winter encampment (1539-40) remains an archaeological site. To the north, the neighborhood of Frenchtown traces its roots to the land grant made to Gilbert du Motier, Marquis de Lafayette on July 4, 1825, a gift made to thank the Marquis for his support of the American Revolution. Farther to the east lies St. Augustine, founded by Pedro Menédez de Avilés in 1565. The city served as the capital of Spanish Florida for two hundred years. In the eighteenth century, two miles north of St. Augustine, Fort Gracia Real de Santa Teresa de Mose was established to receive Africans who had escaped and sought freedom from Caribbean British colonies. Indeed, since Juan Ponce de León's "discovery" of Florida in 1513, the region's governance has oscillated among the same European powers that dominated the Caribbean. Accordingly, Florida has served as a point of connection among empires, peoples, and commodities. These, among other historical complexities, speak to the interconnectivity of the territory's colonial past and its entanglement with native populations, slavery, and plantation culture. From Florida's reliance on immigrant and sometimes "illegal" agricultural laborers to the notion of Miami's status as a gateway to Latin America, the state continues to be entangled within the cultural currents of the Caribbean. As curators, we acknowledge the complexity of Florida's past, and its present, by raising questions about the heritage of this region in relation to the history and legacy of Caribbean colonial cities, institutions, and rural landscapes. In so doing, we implicate Florida in the transoceanic networks that converged, economically and materially, at the locus of the plantation system, which existed in Tallahassee as well as the former French colony of Ste. Domingue. The work of Haitian artist Edouard Duval-Carrié reveals this history in a way that reorients its focus to the people, places, and processes at the center of these colonial systems of production.

This exhibition adopts the theme of "refinement" and seeks to decolonize this notion through a juxtaposition of art and historical artifacts from the

southeastern United States with Duval-Carrié's contemporary work. Just as Duval-Carrié's work comprises the accretion of layers of meaning and material, so, too, this exhibition embeds historical objects among his works. This exhibition thus dredges up the material residues of colonialism that permeate our contemporary landscape in the guise of refinement. Refinement in the larger sense of Southern and Atlantic World history becomes not only the refinement of sugar, cotton, and other raw materials for consumption in the Western marketplace, but also the dominant order's social performances of refinement through art, architecture, manners, music, and dance.

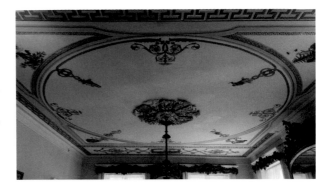

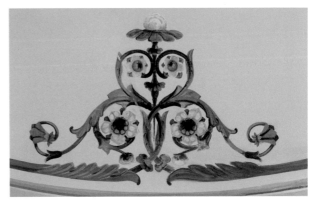

The visual arts comprise and enact hegemonic structures of race, class, and gender that are central to the practice of social and aesthetic refinement. The Goodwood Museum and Gardens in Tallahassee preserves a plantation main house built in the 1830s and adorned with a set of ceiling murals in its ground-floor parlors. Allegories of the seasons co-mingle with those of the discovery of fire and water. The circular framing of this mural in the front parlor is dotted at symmetrical intervals by cotton motifs, historically the plantation's principal crop. This particular pyramidal cotton ornament is composed of a number of flowers entangled in an acanthus-leaved vine that wraps around a decorative spindle crowned with a gleaming white cotton boll. The ceiling overall suggests the planter's control of the agricultural cycles, the primordial valorization of his enterprise as though rooted in humankind's most essential discoveries, and the seasons that can be harnessed to produce a commodity for global world consumption. Removed from the context of their production, in this case by enslaved laborers, the value of these transnational commodities, such as cotton, becomes lost to the laborers and the use value of their products. Yet, in this space of refinement, the murals trained the gaze of cotton-clad antebellum spectators away from the inequities of the global world system, the slavery upon which the enterprise was built, and the darker side of commodities with the beauty and ornamentality of the cotton set with a matrix of classicizing motifs. In the early modern West, including its colonies abroad, art often functioned to enchant its audiences with the refinement of technique and ornamentation, thereby obscuring unequal social relations and the means of production behind a veil of coded aesthetics.[1]

▲[top] Ceiling fresco, Goodwood Museum and Gardens, Tallahassee, Florida. Photo credit: Owen Enzor.

▲[center] Cotton motif, ceiling fresco detail, Goodwood Museum and Gardens, Tallahassee, Florida. Photo credit: Owen Enzor.

▲[bottom] Allegory of Spring, ceiling fresco detail, Goodwood Museum and Gardens, Tallahassee, Florida. Courtesy of Goodwood Museum and Gardens.

1 Anthropologist Alfred Gell critiques what he calls a "cult of art," that he argues has had the effect of commanding a moral authority over Western society by means of the enchanting nature of technology. See Alfred Gell, "The Technology of Enchantment and the Enchantment of Technology," in *Anthropology, Art, and Aesthetics*, eds. Jeremy Coote and Anthony Shelton (Oxford: Oxford University Press, 1992), 40-66.

The exhibition "Decolonizing Refinement" contributes to this nascent discourse of critical artistic investigations into the fraught and political modalities of enchantment by deploying complementary meanings of refinement. On the one hand, refinement describes the processes by which a resource becomes a product—cane to sugar, pine resin to turpentine, or cotton to textiles. On the other hand, the term refers to the systems of etiquette and taste that proscribe social behavior and valorize unequal systems of production and consumption. These complementary meanings, we suggest, locate the demand, manufacture, and consumption of commodities within the theater of the colonial world. We conceive of the colonial period, which haunts us still today, as the historical era of global world history begun in 1492 when certain political and social structures of racism and patriarchy emerged from the expansion of European empires and transoceanic commerce. These colonial structures, foundational to modern capitalism, mark a new kind of ecology, in which all things, including people, could be commodified, and their value configured by an abstract world market. This theater of globalized production and consumption, commodities, and the insatiable Western drive for "refinement," both social and material, has become the world stage upon which modernity / coloniality promotes and propels itself.

The work of Edouard Duval-Carrié often engages and complicates the legacy of refinement in the Caribbean, particularly that of his native Haiti, both from within and without. He is an artist *of* the modern / colonial world—he incorporates the very products of modernity into his work, from plastics to photographs—and an artist *about* that same world—cleverly juxtaposing refined materials with images to critique the processes of modern fabrication through historical systems of oppression, stratification, and invisibility. Even Duval-Carrié's studio exhibits this dual tendency. Tucked away in Miami's Little Haiti Cultural Complex, his studio opens up into an impressive site. To one side, a stunning sitting area replete with an extensive library and artifacts from across the globe is carefully arranged to produce the intoxicating effect of a nineteenth-century salon. Across the threshold, the artist's workspace espouses a materiality of excess—drawers, filled to the brim with knick-knacks and industrial materials, beads, plastic toys, cut-out shapes, lots of glitter—that transform the space, and the works produced within it, into a laboratory of and about refinement.

Duval-Carrié's work, especially his most contemporary pursuits, brings to light the recursive patterns of colonialism and exploitation in the processes of refinement that heralded the birth of the modern / colonial world system. For the artist, the Caribbean becomes not merely a case study for these broader global dynamics, but rather the crucible from which our modern, industrial age emerges. Duval-Carrié's oeuvre centers on his native Haiti, where colonial sugar plantations largely funded the Francophonic age of Enlightenment. He emphasizes the ties between this history of exploitative labor, the Haitian Revolution—the only successful slave revolt in the early modern Atlantic world that transformed France's most lucrative plantation colony into a sovereign nation—and contemporary Haiti's transatlantic consciousness.

In a departure from his earlier portraiture and paintings, his recent body of work harnesses the historical circumstances of refinement as the raw material for his own bricolage process. Like many contemporary artists, Duval-Carrié engages modernity by posing questions, for instance, about how and why imperial Western culture will continue to expand in terms of the now deeply entangled spheres of industry, landscape, food security, and migration. However, he explores such contemporary pursuits by thinking through the past. He uses the archives of human production—objects, images, landscapes—to rediscover the ways in which, to invoke his own phrasing, our modern / colonial world has been "coded" (Wolff, this volume).

Sugar Conventions, the work of art from which this exhibition and collaboration emerged, clearly demonstrates Duval-Carrié's method of historic bricolage. This mixed-media piece, produced by the artist for the Winthrop-King Institute for Contemporary French and Francophone Studies at Florida State University

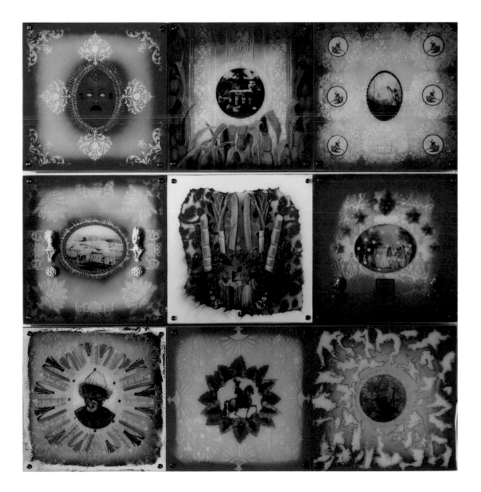

◀Edouard Duval-Carrié, *Sugar Conventions*, 2013, mixed media on backlit Plexiglas, 72 x 72 inches. Courtesy of Winthrop-King Institute for Contemporary French and Francophone Studies, Florida State University, Tallahassee, Florida.

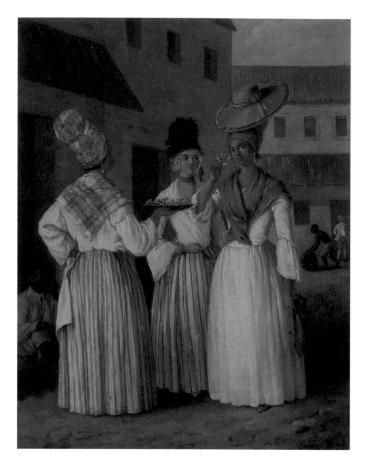

Agostino Brunias, *A West Indian Flower Girl and Two other Free Women of Color*, ca. 1769, oil on canvas. Yale Center for British Art, Paul Mellon Collection. Public domain.

in 2013, comprises nine gridded tiles, each of which contains an image that alludes to Caribbean society, real and imagined, historical and contemporary. Of the nine central images embedded in the tiles that make up *Sugar Conventions*, none is unique to the work. Rather, Duval-Carrié has excerpted passages from archival paintings and photographs and inscribed them into his art, layering them between pieces of Plexiglas like a specimen under a microscope. In *Sugar Conventions*, and elsewhere in his work, Duval-Carrié invokes the eighteenth-century Italian painter Agostino Brunias (1730-1796), whose idyllic, romanticized scenes of the British West Indies became the means through which much of Enlightenment-era Europe encountered the Caribbean.[2] Duval-Carrié uses Brunias's renderings of a beautiful young flower-seller and a group of free women of color to punctuate that which is *not* portrayed, namely the brutality of enslaved labor essential to plantation culture and economy.

The ways in which Brunias veiled the horrors of enslavement did not make the realities any less gruesome for those kept under the institution's heavy hand. Sugar plantations dominated Ste. Domingue and thus garnered enormous wealth for the French Crown.[3] This wealth came at a massive human cost. Enslaved laborers frequently lost life and limb in the service of sugar cultivation and refinement. Sugarcane is a demanding crop and sugar refinement labor intensive and dangerous. The seasonal variability of the cane coupled with high commercial demand required around-the-clock labor to harvest the matured crop. The cane is volatile, prone to quick degradation, which only worsens in the more northern climates where sugar was historically cultivated along the US Gulf Coast, such as Louisiana and Florida. Laborers thus had to harvest the crop rapidly. The gathered cane immediately required crushing and juicing before rot set in to the stems. Enslaved plantation workers quickly forced the cane through a mill of wooden rollers to extract the juice—a perilous step that often resulted in the loss of fingers and hands, and at times death. Duval-

2 Duval-Carrié has frequently cited Kay Dian Kriz's *Slavery, Sugar, and the Culture of Refinement: Picturing the British West Indies, 1700-1840* (New Haven, CT: Yale University Press, 2008) as a formative text in his understanding of the function of sugar in shaping Western aesthetics and his understanding of Brunias' paintings in that context.

3 Christopher Columbus first introduced sugarcane to the island of Hispañola during his second voyage in 1493. Prior to his transatlantic travels, Columbus gained experience with sugar cultivation as an apprentice in Madeira's sugar trade, under the auspices of the Portuguese Crown, in the 1470s. See Judith A. Carney and Richard Nicholas Rosomoff, *In the Shadow of Slavery: Africa's Botanical Legacy in the Atlantic World* (Berkeley, CA: University of California Press, 2009), 38.

Carrié gruesomely portrays this process in *L'Accident a la Guildive* (2017), an etching from a scene in Alejo Carpentier's novel, *The Kingdom of This World*.[4] In this image, he depicts the novel's main character, an enslaved laborer named Makandal, severing his hand after an accident in the wooden rollers of the sugar mill. Those not forced to work the rollers faced other horrors. After extracting the juice by pressing or pounding the crushed cane, enslaved laborers reduced the liquid in a boiling cauldron that posed its own dangers of severe burns or death. The goal, refining raw cane from Caribbean lands into "pure" white crystals for European consumption required extremely high yields of raw material—twenty tons of cane produced just one ton of raw sugar.[5] The high demand for refined sugar ensured that these taxing processes continued at a swift, and thus treacherous pace. It also rendered sugar plantations violent sites of both agriculture and industry.

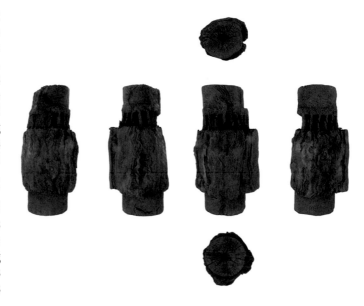

Duval-Carrié does not wish to mask the harsh realities of plantation slavery from the viewer, but rather to explore how—to again use his own term—the "politeness" of artifice not only veils, but also engenders and enables the horrific production and consumption of refinement. In *Sugar Conventions*, he thus glazes Brunias's "saccharine" images with a coating of refined sugar crystals. Layered one over another, sugar becomes historicized and aestheticized, while Brunias's idyllic scenes are then inscribed with the urgency of contemporary industry. Duval-Carrié thus employs sweetness to subversive ends, drawing in and then enchanting the viewer, only to reveal upon closer examination how the object of desire, be it art or sugar, actually serves as a tool of destruction and violence. The artist situates the subject, the thing, as the key to unlock the disparity between artifice and existence. The physical layers of Duval-Carrié's work thus function as a conceptual framework for the fraught dynamics among visual representation, material production, and social reality.

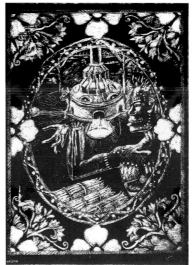

In *Sugar Conventions*, Duval-Carrié presents the viewer with actual sugar encased under a thick layer of acrylic. By incorporating literal sugar he creates a parallel between the veritable manufacture of this commodity and the production of his own work that documents the visual culture and the historical effluvia of such products. The commodity, be it sugar or cotton, thus

4 See Sidney Mintz, *Sweetness and Power: The Place of Sugar in Modern History* (New York, NY: Penguin Books, 1985), 21, 49-50; see Ira Berlin and Philip D. Morgan, "Labor and the Shaping of Slave Life in the Americas," in *Cultivation and Culture: Labor and the Shaping of Slave Life in the Americas*, ed. Ira Berlin and Philip D. Morgan (Charlottesville, VA: University Press of Virginia, 1993), 9.

5 Arthur Stinchcombe, *Sugar Island Slavery in the Age of Enlightenment: The Political Economy of the Caribbean World* (Princeton, NJ: Princeton University Press, 1995), 49.

▲[top] Wooden roller "trapiche" from sugar mill, 29 x 13½ inches. Courtesy of the Florida Division of Historical Resources.

▲[bottom] Edouard Duval-Carrié, detail of *L'Accident a la Guildive,* from *The Kingdom of This World* series, 2017, engraving on Plexiglas, 31 x 27 inches.

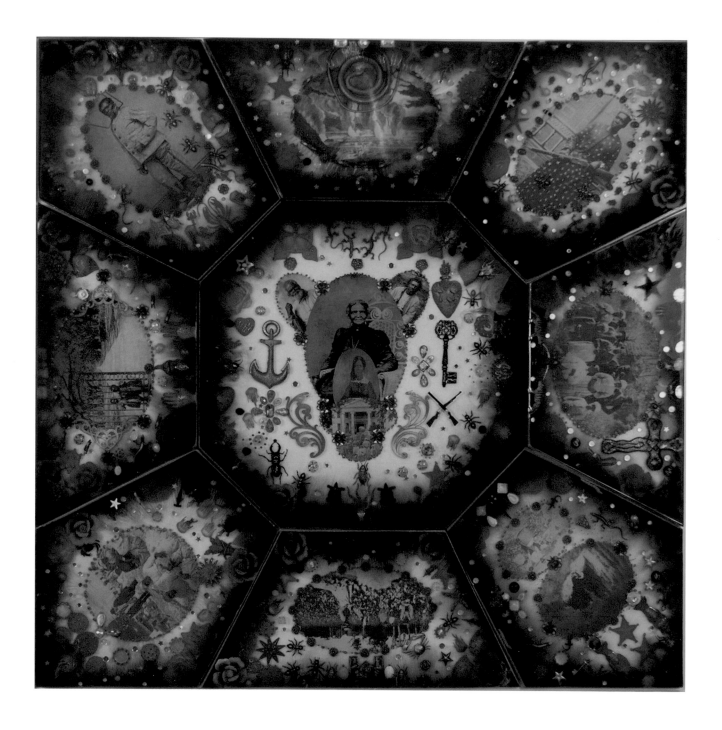

accentuates the parallel between industrial fabrication and Duval-Carrié's own artistic mode of refinement. The presence of sugar and cotton ultimately bind these processes and serve as relics of the processes of their manufacture—tangible mementos of labor. Instead of the gold and gems of a religious icon, a reliquary of historical photographs, Plexiglas, and resin contain these treasured products; nevertheless they instill in the work a presence akin to sacra that ensoul a religious image.

That Duval-Carrié's works have been taken up to serve as sacred objects points to the validity of the interpretation that sees his art as analogous to sacred imagery. In Peter Sutherland's contribution to *Continental Shifts* (2007) he describes a conference that he had organized at Louisiana State University, where Duval-Carrié had "jumped up from his front-row seat, walked over to the screen and pointed at the sculptures of the pythons and crosses, shouting: 'Hey! Those are *my* sculptures! He's turned them into fetishes.'" The artist was referring to the co-option of a series of objects that he had originally designed for the Ouidah 92 Reunion. Duval-Carrié's installation of these sculptural, spiritual antennae along a half mile of Ouidah's coastline recall the rituals held on the beach in Haiti that were performed to reunite the souls of ancestors with their African origins. Reversing this process, the Ouidah installation was designed to guide ancestral spirits from their home in Haiti back to Benin, the place from whence they had been sold into slavery. However, before Duval-Carrié could stake these sculptures into the sand, Daagbo Hounon, Benin's Supreme Chief of Vodun, requested that they be relocated to the entrance of his palace. He intended to re-situate them at this threshold not as works of art, but rather as powerful, religious fetishes. Upon his return to the beach, Duval-Carrié found that his sculptures had been removed and repurposed. His work had so effectively evoked the sacred that it became ritual instrument.

Duval-Carrié often complicates the border between art and "fetish." Edward Sullivan has suggested that his early works actively sought to "re-sacramentalize" the museum through the incorporation of Vodou symbols and imaginings.[6] As his recent production demonstrates, the artist now extends this spirituality beyond a pictorial likeness and into the very materials and processes comprising the work itself. Duval-Carrié's most recent pieces, such as *Memory Window #4* (2017), largely comprise layers of accreting materials and images as a means of invoking the sacred through the art object. Like *Sugar Conventions*, an ethereal glow surrounds the resin panels of *Memory Window*, produced by glittering substances adhered to their surface and interior illumination. These captivating layers render his works as objects of ritual at the same moment that they ask the viewer to consider the

◄[facing page] Edouard Duval-Carrié, *Memory Window #4*, 2017, mixed media embedded in resin in artist's frame, backlit, 58 x 58 inches. Image courtesy of the artist.

6 Edward J. Sullivan, "Continental Shifts: Edouard Duval-Carrié and the Re-Invention of the New," in *Continental Shifts: The Art of Edouard Duval-Carrié*, ed. Edward J. Sullivan (Miami, FL: American Art Corporation, 2007), 22.

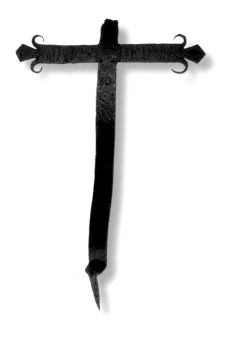

ritualization and the former lives of the objects encased within them.[7] Duval-Carrié thus imbues sacrality into materials in order to reframe, or perhaps decommodify, the precious, vital nature of these products in historical terms.

Memory Window's glow invokes the numinous through its transient radiance, but it also loudly articulates the work's prominence in the stark space of the museum gallery. The light makes the work known—visible—in the same instance that it invokes the unknown—the invisible. This spectacle of (in)visibility resonates with the photographic memorabilia layered into this "window." The work foregrounds portraits of enslaved, or formerly enslaved, laborers, and sharecroppers from northern Florida and southern Georgia enshrined in a watery, purple haze. The central photographs show men and women looking head on at the viewer, their gazes unrelenting and their agency as sitters evident. Nonetheless, the camera's lens cannot help but objectify its subjects. In this manner, the photograph perpetually refers back to the condition of enslavement and commodification of the sitter. This seems to be a fundamental paradox of refinement: it demands invisible labor to create the most visible of products. Thus, while these products are upheld as the paragon of civilized achievement, the people who labored and suffered in the service of these material processes are relegated to inhuman status, their mark on the material world unacknowledged. The photographs in *Memory Window* push back against this tendency to dehumanize and veil enslaved labor, yet the commodification and objectification of the image remains a persistent reminder of the problematic (in)visible legacy of the enslaved.

An iron cross from the slave burial site of Oakland Plantation, Louisiana, further attests to the desire to humanize the enslaved by inscribing their presence on the land and to therefore attain a sense of social agency, even in death. A beautiful cross with fleur-de-lis foliation at the end of the arms declares the name "JOSEPH" incised in bold lettering across the horizontal bar. This iron cross marked the grave of an enslaved man whose personhood and legal entitlement to land had been denied in life, but whose name and material presence proclaims an active negotiation of social selfhood, even in death. The refined cross, material evidence of an enslaved heritage and its value systems, persists, like a photographic image, as a vibrant remnant of a lived past, marking the absence of life through death.

This oscillation between presence and absence manifests in *Memory Window* through the white light emanating from the work, which renders its photographs visible along with the relentless gaze of the sitters, one of whom, at top right, even brandishes a weapon. Krista Thompson identifies dramatic lighting such as this to be a marker of presence and excessive performativity, although to spectators, Thompson notes, these performers, like the sitters in

▲Tombstone, strap form cross, iron, 18.84 x 32.4 inches, originally from Oakland Plantation Cemetery. Image courtesy of the Southeast Archaeological Center, US National Parks Service.

▶[facing page] Edouard Duval-Carrié, *Sugar Bun and Sugar Puff*, 2017, installation view from the Museum of Contemporary Art, North Miami, 9 x 9 feet each. Image courtesy of the artist.

7 In his seminal work on the transatlantic relationship between sugar production and modernization, Sidney Mintz suggests that sugar became "ritualized" in British society both through its incorporation into the performative nature of everyday life as well as the perceived conceptual and historical continuity between sugar and one's sense of identity or intrinsic sense of belonging. See Mintz, *Sweetness and Power*, 122.

the photographs, remain unseen or "unvisible," a term first coined by Ralph Ellison.[8] Duval-Carrié materially conjures these conditions of unvisibility in *Memory Window*—through the many uncanny objects enshrining the photographs, or even the sitters themselves, who defy subjugation with their gaze—to ask how the colonial veiling and displacement of enslaved bodies manifests in the aesthetics and materials we value today. This refusal of existing social and political structures—"highlighting the limits of existing structures"[9] by literally *high-lighting* their aesthetic and material make-up—through which Duval-Carrié engages in his decolonial practice, breaks down the very mechanisms of refinement that he brings to bear on the gallery.

Duval-Carrié's efforts to re-sanctify the museum and the processes and products of refinement again converge elegantly in the large-scale sculptural installation *Sugar Boat* (2017). The large form of a boat, painted stark white with abstracted stars shooting out from its sides, is suspended weightlessly from the ceiling. Numerous resin anemones hang from thin wires, like fireflies, around the perimeter itself sparkling with glitter. Airy and gleaming, the ship transforms the gallery into an oceanic seascape, and the viewers into *ambaglos*, reverential Vodou ancestral figures that live beneath the water and which Duval-Carrié portrays as bodies floating in vegetal space in *La vraie histoire des Ambaglos*

8 Krista Thompson, *Shine: The Visual Economy of Light in African Diasporic Aesthetic Practice* (Durham, NC: Duke University Press, 2015), 39-40.

9 Ibid, 41.

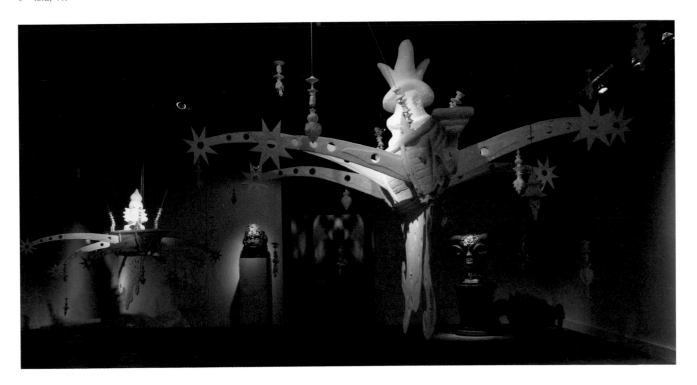

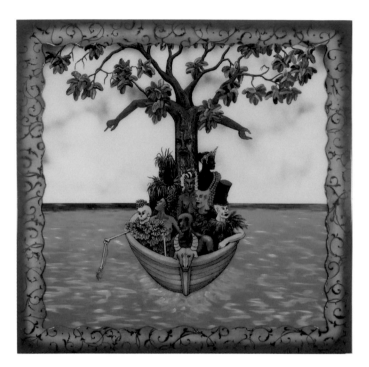

[*The True History of the Underwater Spirits*] (2003). Indeed, Duval-Carrié invokes the sacred in *Sugar Boat* through both explicit and implicit renderings of Vodou symbolism. The boat itself is a manifestation of the *lwa* [Vodou deity] Agwé, Lord of the Sea, whose likeness Duval-Carrié has earlier portrayed in *Agwé* (1994), as a humanoid form with tentacles upon his head who sits waist deep in a body of water dotted with vegetation. Agwé's attributes emanate from *Sugar Boat*—the color white, seashells, boats, and cane syrup (liquid sugar)—thus rendering the gallery a site of spiritual invocation particularly attuned to "whiteness" and sugar. The seven-sided shooting stars protruding from the boat symbolize the *lwa* Ezili Danto, the defender and protectress often portrayed as Agwé's wife, whom Duval-Carrié has depicted alongside Agwé in *Le Dahomey ou la Descente d'Erzulie* (1994). The stars on *Sugar Boat* that call upon Ezili also signify the key to Ginen, the ancestral and mythic Vodou homeland that may only be reached in the afterlife by undersea travel.

In *Sugar Boat*, as in *Sugar Conventions*, Duval-Carrié thus foregrounds the perpetual quest for the road home as a product of displacement, both from the historical institution of slavery and from modern-day oppressions that continue to force Haitians and other Caribbean citizens to migrate from their adoptive homelands. The boat becomes the literal and figurative vehicle in this eternal search for home. Duval-Carrié draws upon the boat motif frequently, in works such as *Le Retable des Neufs Esclaves* (1989), *After Bierstadt: The Landing of Columbus* (2013), and *Le Traversée* (2016), where discontentment, the uncanny, and inbetweeness become fixed states of being. The *Sugar Boat* thus materializes in the gallery as a fictive relic of the Middle Passage, a persistent reminder of the commodification of the land and of the people who worked the land in the service of refinement; it is also a reminder that relics of labor, production, and forced migration have been suppressed if not wholly erased from the visual record, even as products of refinement, like gleaming white sugar crystals, or even Duval-Carrié's work itself, are continually valorized. Neither humans nor ships remain from these transatlantic voyages, rendering the luminous boat as much an imagined cultural absence as a spectacular museal presence.

Duval-Carrié reimagined a previous sculptural work, *Boat in Field of Anemones Waiting for the Spirits* (2006), as the foundational form for *Sugar Boat*. The self-referential underpinnings of this work—as a representational conflation of Duval-Carrié's past and present creations—further confounds the "presence" of the boat. Its glitter lends a luminosity that, like *Memory Window* and *Sugar Conventions*, proclaims its existence in the gallery while also threatening to disappear, like a shapeless, colorless ghost, into the "white

cube." The boat sparkles like a jewel, signifying a preciousness that may be read as the privileged value of the art object in the museum. This gleaming quality also reads to the eye as the preciousness of sugar, a mundane commodity, but with a value that nonetheless shaped the modern world. In both cases, the art object and the foodstuff, the value of the object transcends its labor input and instead becomes marked by the social performativity of refinement. By referencing commodification alongside notions of material and conceptual presence and absence, in the museum gallery no less, Duval-Carrié attempts to fold the previously hidden labor, and societal costs, of refinement back into the perceived value of its products.

In this manner, *Sugar Boat*, and all of Duval-Carrié's contemporary pursuits, reference transformation as well as transubstantiation. The artist's relics draw our awareness not just to what we see—sugar—but to that which remains hidden from plain sight—the persistence of the colonial into today. Therefore, it seems no coincidence that Duval-Carrié's work so heavily invokes Vodou imagery and symbolism. The artist materially engages Joan Dayan's suggestion that Vodou, "must be viewed as ritual reenactments of Haiti's colonial past."[10] In short, the colonial past, by the very nature of its coloniality, finds itself embedded, materially and socially, in the modern present. The oscillation between past and present in Duval-Carrié's work, through light, space, image, and commodities, engages a fluxus of space and time that reveals gateways into aspects of our circum-Caribbean heritage that have persisted unseen and unappreciated. The slippages of Duval-Carrié's work, the perceived fragility of his constructions, the permanence of their impermanence, render his works as active decolonizing agents.

What began years ago as a discussion with Duval-Carrié about refinement and its relationship to Caribbean history has slowly rippled out into a pursuit of the layers that today comprise North Florida's history and heritage. Through this pursuit, we discovered how profoundly the mechanisms of refinement— namely, transformation and commodification, of the land, of its processes and products, of its people—reside in the Forgotten Coast of North Florida. Indeed, we dwell in a region that has largely been invisible to the rest of the country, but its transformations have been real. One need only look to the "living history" enacted at Mission San Luis or the architectural ruins of Verdura Plantation that lie dormant beneath the region's lush flora, to understand North Florida's heritage not as a palimpsest of erasures, but rather as densely knotted and "multidirectional" socio-cultural threads.[11]

Colonialism never fully obliterated the history, heritage, and humanity of subjugated populations; rather, colonialism has made that history, heritage, and humanity difficult to locate. As some images continue to mask socio-

10 Joan Dayan, *Haiti, History, and the Gods* (Berkeley, CA: University of California Press, 1995), xvii.

11 Michaeline A. Crichlow, *Globalization and the Post-Creole Imagination: Notes on Fleeing the Plantation* (Durham, NC: Duke University Press, 2009), 2.

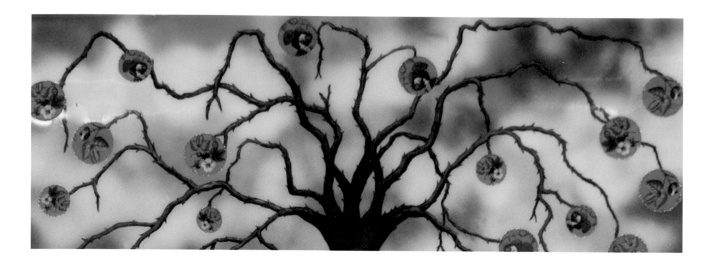

economic inequities in today's world, other images, like those by Duval-Carrié, work to bring these imbalanced structures into view. In Duval-Carrié's *Of Cotton, Gunboats, and Petticoats* (2017), colonialism manifests as an urgent presence into which the past has been literally and figuratively inscribed [for full image see page 39]. An anthropomorphic tree wears a pleated blue dress with white puffed sleeves and a red and white necktie—together these colors signify the US, France, and Haiti. The colors appear serene and inviting—enchanting—yet this tree points downward, quietly alerting the viewer to the sinister scene below of a militarized ship she straddles between her feet while Haiti alights in flames. The tree possesses not roots dug into the earth, but rather feet firmly planted atop the ocean, which remain literally chained to the land via a stake in the ground that tautly shackles the tree. The branches seem bare and uninviting with small thorns emerging from all sides. Along these branches, small medallions perpetually bloom. Of the genus *Gossypium* (cotton), these blossoms are portrayed in various states of bloom, from the delicate flower that first blossoms to the boll, the pod from which the cotton fibers emerge, also depicted on the ceiling of Goodwood Museum's parlor, which only materializes after the flower has bloomed and wilted. This cycle of life and death seems a deceptively entrancing nod to the backbreaking labor of harvesting that the blooming cotton would soon demand. Duval-Carrié appropriates the illustrations of these blooms from historical sources, which would have been used not only to entice viewers with their beauty, but also as empirical documents to justify the fervent colonial pursuit to exploit resources and enslave humans.[12] Duval-Carrié brings these historical documents into his contemporary work, rendering the work uncanny, in a state of un-knowability that has been further amplified by the disorienting "googly eyes" used to enliven the tree's gaze.

▲Edouard Duval-Carrié, detail, *Of Cotton, Gunboats and Petticoats*, 2017, mixed media on aluminum artist's frame, 72 x 60 inches. Image courtesy of the artist. For full image, see page 39.

12 See Daniela Bleichmar, *Visible Empire: Botanical Expeditions and Visual Culture in the Hispanic Enlightenment* (Chicago, IL: The University of Chicago Press, 2012).

The imminent presence of this surface, further marked by its textured foreground, and its invocation of empire, "rootlessness," and resources reminds us that even though official institutions of enslavement have ceased in our own nation, colonial systems of production and consumption persist and move through the global oceanic channels, as unseen and unacknowledged as they were in the past.

Over the years, in conversation and collaboration with both Duval-Carrié and local institutions, we have come to see how deeply entangled the heritage of the Forgotten Coast has always been with Duval-Carrié's Caribbean. Less than twenty miles directly south of Tallahassee, the sleepy town of St. Marks sits at the confluence of the Wakulla and St. Marks Rivers. These pristine waters slowly feed into Apalachee Bay and ultimately into the Gulf of Mexico. Along the waterfront, an historic marker tells the story of Port Leon, a short-lived town just south of St. Marks. The town centered on a railroad terminus constructed with the expressed purpose of transporting cotton in and out of the region in the 1830s and 1840s, thus taking the product of enslaved labor far from the oppressed producers and onward to the conspicuous consumers. In 1843, a hurricane swiftly wiped the railroad terminus off the map. Today, in its stead, a marker reminds us of the "Ghost Town" that once stood in this bucolic landscape, an historical site now invisible yet persistent, which itself once wrought enslaved labor invisible yet its products persistent. We thus convene at the Museum of Fine Arts in pursuit of bringing Duval-Carrié's vision of refinement into conversation with the materials and images—the archives of production—that comprise North Florida's artifice and reality.

— *Lesley A. Wolff, Michael D. Carrasco, and Paul B. Niell*

▲Mexican Cotton in bloom (*Gossypium hirsutum*). Image courtesy of Michael D. Carrasco.

Making History and the Work of Memory in the Art of Edouard Duval-Carrié

Anthony Bogues

". . . the history reflects the pressure and the passage of lava, storm, stone earthquake, crack, coral; the rise and fall of landscapes; destructions, lost memories . . . Creation: fragments . . . breathing air, our problem is how to study the fragments / whole."
—Kamau Brathwaite, *Savacou* (1975)

"As far as we are concerned, history as a consciousness at work and history as lived experience are therefore not the business of historians exclusively."
—Edouard Glissant, "The Quarrel with History" (1976)

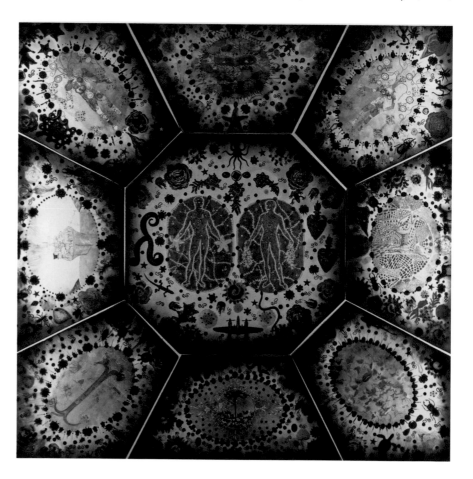

▶Edouard Duval-Carrié, *Memory Window #2*, 2017, mixed media embedded in resin in artist's frame, backlit, 58 x 58 inches. Image courtesy of the artist.

Introduction

The matter of history within the Caribbean is a complex one. What are the forms of historiography? How should we understand the question of archives? What is the work of memory in creating history in Caribbean thought and culture? How do we grapple with history when the vast majority of the Caribbean people lived inside historical periods in which colonialism and racial slavery were forms of power that operated through technologies of domination in which might was right? How does one write, think, and make history in the contexts where violence was both the inaugurating and then sustaining form of rule over bodies and subjects.[1] For some time these questions have been alive, but today seem to have superseded with narrow disciplinary preoccupations. Two exceptions of note have been a work of literature, specifically Patrick Chamoiseau's novel *Texaco*, and the art of Edouard Duval-Carrié.[2]

There are immediate sets of questions and debates in Caribbean thought and culture in which the question of history is probed. The key issue is not so much about the making of history, nor the conventional issue of "whose history," rather, it is a question about the possibility of history itself. Included in this are discussions about how to periodize Caribbean historical narratives and what work memory does in any construction of history.[3] Here I make a set of distinctions between memory and history which the reader should hold tentatively because in the end history in the Caribbean is not simply about formal historical knowledge. The contingency of historical truth, while routed through the events of a historical process, is composed of understandings and knowledges about the past; but, in a profound way, these understandings are about how the past lives in the present. To put this another way: one conventional way to think about the past is to say "the past shapes the present." Yet what happens if we decide to understand the past through the present, not as a form of presentism, but as way to grapple with the meanings of the present? At that moment, the past becomes an open-ended passage to think with and to understand what we are in the present. This kind of thinking about history is, I would suggest, critical to what Kamau Brathwaite called, in 1976, "an archaeology of selves." It is, I would want to argue, a central feature in the artistic oeuvre of Edouard Duval-Carrié.

1 There were of course other forms of rule within the Caribbean society, so, for example, within the post abolition period in the British colonial Caribbean, there were attempts to develop forms of rule in which refashioning the subjectivities of the ex-slaves was the technology of rule. However, might was never far away and deployed when necessary. For a discussion of this, see Brian Moore and Michele Johnson, *Nether Led nor Driven* (Kingston: University of the West Indies Press, 2004).

2 One cannot ignore the seminal work on history by Michel Rolph Trouillot, *Silencing the Past: Power and Production of History* (Boston, MA: Beacon Press, 1997). However, this remarkable text, which works around the issues of general silences in historical writing and suggests a constructivist approach to history while repositioning the dual Haitian Revolution as critical to the making of the so-called modern, does not think through the ways in which a historical catastrophic lives its afterlives, how history lives in our bones, to paraphrase James Baldwin.

3 See in *Texaco*, the ways in which the history of Martinique is divided through the materials for building houses.

In the Caribbean, the debate over history has many sides to it.[4] In this essay, I would like to briefly draw attention to three figures because their ideas open up a framing space for us to grapple with the conception that one foundational feature of Duval-Carrié's work is that it engages *living history*. Before we proceed to the figures, we should spend a little time thinking about the meaning of *living history*.

To engage in historical practices that can be called *living history* does not mean that one practices forms of anachronism, in which the past is read into the present. Instead, working with Walter Benjamin, it is to operate within an understanding of how the past flashes up before us, not just in moments of danger, but as traces, sedimented deposits and fragments which re-articulate themselves sometimes in new forms. It is about how historical deposits are alive and can become what has been call, "Dread History."[5] In a previous discussion about history, I noted that within the historical imagination and discourse of Rastafari, there was a conception of "Dread History." In this conception of history, there was a preoccupation with the now, but the language in which the now was framed drew from past historical events and persons. I would argue that there is a similar imaginative process of working with history in many African diaspora religions. Duval-Carrié's historical sensibility was initially rooted in the symbolic universe of Vodou, and therefore, it is not surprising that the form of history that he practices draws from the ways in which many African Diasporic religions work through history. In this practice of history, for deposits to be alive, their form becomes repeatable. However, we should note that repetition does not mean the same, rather it can mean the creation of difference and the new.[6] I would also suggest that practices of *living history* seem to be crucial to the contemporary experiences of human populations that have been dominated by colonial power. In the end, *living history* is a historico-critical practice in which history becomes a way to critique the present.

History and Caribbean Thought

Brathwaite's 1976 essay in *Savacou* on space and time in the Caribbean noted that there are various models for the study of Caribbean society. In the 1970s, one of the most pervasive sociological models was that of the plantation, and he notes that the model, "is itself a product of the plantation and runs the hazard of becoming as much tool as tomb of the system that it

4 One of the most important participants in this debate was the historian Elsa Goveia. See her essay, "A review of Eric Williams's 'British Historians and the West Indies'" in John La Rose (ed.), *New Beacon Reviews : Collection 1* (London: 1968). For Haiti there was an earlier debate; see, for example, Henock Trouillot's 1954 book *Historiographie d'Haiti*.

5 For a discussion of Dread History, see Anthony Bogues, *Black Heretics & Black Prophets: Radical Political Intellectuals* (New York, NY; Routledge, 2003), and Robert Hill, *Dread History: Leonard Howell and the Millenarian Vision in the Early Rastafarian Religion* (Chicago, IL: Frontline Distribution International, 2001).

6 In musical composition, for example, the rendering of the same song twice or thrice is always done with different nuances.

seeks to understand and transform."[7] Because of this, Brathwaite argues that to understand the Caribbean required working with what he called the "inner plantation." This form of the "inner plantation," he stated was concerned with "cores and kernels; resistant local forms; roots, stumps, survival rhythms; growing points."[8] In this he was arguing for a different epistemological focus in our study of history.

This shift of gaze both archivally and intellectually meant that the history and the recounting of historical events as historical knowledge was now a different terrain. It was about discerning cultural practices of signification in which the symbolic world was the focus. Sylvia Wynter, in her work on dance in Jamaica written in 1970, recognizes the need for different forms of historical interpretations other than the ones which had by then become standard. Drawing extensively from the writings of the Haitian intellectual Jean Price Mars, she noted that his study of the so-called folk culture in Haiti pointed to a process of "indigenization." Such a process, she observed, meant that Caribbean history was not a written history but rather was a "cultural history— not in writing but of those homunculi who humanize the landscape by peopling it with gods and spirits, with demons and duppies, with all the rich panoply of man's imagination."[9] To put the matter differently, the historical process for the ordinary Caribbean person was not about what was written, but rather it was about grasping the living present and the ways in which the historical systems of colonialism and racial slavery had created grounds for life that required new forms of cultural life, symbolic orders and forms of criticism. It is within these forms that one finds an alternative history of the Caribbean. The novelist Wilson Harris puts the matter well when he writes that what was required within the historiography of the region was to understand that there was a philosophy of history which was, "buried in the arts of the imagination."[10] For Harris, the limbo dance and the practices of Vodou represented sites where this philosophy of history could be found. I would wish to argue that critical to this kind of "philosophy of history" is the work of memory.

In recent work around the relationship of memory and history, there is the argument that even though historians have taken into account oral history as a form of memory, there is incompatibility between memory and history. Memory is considered as the simple operation that recalls the past, while the writing of history is anchored within archives. However, as Pierre Nora has noted, there is a collective memory which can be defined as "what remains of the past in the lived reality of groups, or what these groups make of the past."[11]

7 Kamau Brathwaite, "Caribbean Man in Space and Time" in *Savacou*, No. 11/12 (Kingston: 1975), p. 4.

8 Ibid, p. 6.

9 Sylvia Wynter, "Jonkonnu in Jamaica: Towards the Interpretation of the Folk Dance as a Cultural Process" in *Jamaica Journal*, June 1970, p. 35.

10 Wilson Harris, *History, Fable and Myth in the Caribbean and the Guianas* (Wellesley, MA: Calaloux Publications, 1995), p. 18.

11 Cited in Jacques Le Goff, *History and Memory* (New York, NY: Columbia UP, 1992), p. 95.

Trying to reverse the conventional difference between history and memory, Nora argues for a kind of history called *Les Lieux de Memorie*. In this form of history what is key is its capacity for "metamorphosis, an endless cycle of meaning, [the] unpredictable proliferation of . . . ramifications."[12] In this work of memory there is no referent.

In the Caribbean, with the exception of Haiti, the work of memory has the referent of racial slavery and the plantation. For Haiti, the referent is the dual Haitian Revolution. Within the domain of historical writing, the revolution and its afterlives dominate the historiography. The early written histories of Haiti, the writings of Moreau de Saint-Mery, Thomas Madiou and Beaubrun Ardouin, in many ways, remain archival material for early Haitian history while those of Baron de Vastey, with its vindicationist defense of the revolution as a force to redeem the black world in the nineteenth century, clears the space for radical nationalist renderings of the revolution.

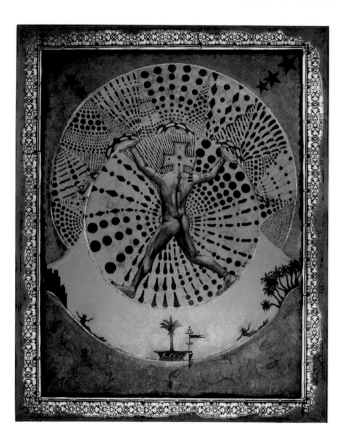

New Archives

As Laurent DuBois makes clear, there need to be new archives of post revolution life in Haiti. Noting that the counter-plantation system, developed primarily by female ex-slaves was one of the achievements of the revolution, he posits the idea that in thinking about alternative archives, "one of the most powerful and useful of these is the corpus of Vodou song, a rich and extensive set of sung texts that offer specific historical references . . ."[13] One of these songs is the historical song *Lapriye Boukmann (Boukmann's Prayer)*. This song, purported to be the incantation of Boukmann, the Vodou priest, remains as poignant as it was in the late eighteenth century. It calls upon the gods of the slaves to come to their aid in the coming struggle, for the *lwas* lived then and continue to live as gods amongst the people being "possessed" and possessing individuals. In this double possession, they make history. It is why the August 1791 Bwa Kayiman ceremony which inaugurated the slave insurrection is painted over and over again in Haitian art. It is not that Boukmann nor Cecile Fatiman invoked the spirit of revolt, rather it is that they invoked the *lwas* to open the way for struggles to overturn slavery and the social and economic structures of the plantation. The painter Andre Pierre understood this well with his

▲ Edouard Duval-Carrié, *Kongo Deme-nageur (Traveling Congo)*, 2005. Image courtesy of the artist.

12 Pierre Nora, "Between Memory and History" in Jacques Revel and Lynn Hunt (eds.), *Histories: French Constructions of the Past* (New York, NY: New Press, 1995), p. 641.

13 Laurent DuBois, "Thinking Haiti's Nineteenth Century" in *Small Axe 44* (Durham, NC: Duke UP, 2014), p. 76.

painting *Guinean spirits returning to Africa after the Haitian Independence War*.

Benjamin Hebblethwaite, in his remarkable book *Vodou Songs*, presents a modern Vodou song, "The Battle Continues."[14] The lyrics of the song begin with the 1503 slave trade that brought Africans to the island of Hispaniola. It then addresses the ways in which colonial power attempted to Christianize the African: "They say we have to have faith, they say we have to be baptized." The song rejects these forms of subjectivities and remembers the ceremony at Bwa Kayiman as one which "did our revolution . . . so that we could truly have freedom." In this song a historical event, the Haitian Revolution, is brought forward as a living memory in the present because as the refrain of the song goes, "the battle continues." All this means we are now on a different terrain to begin to understand how history as event is not only made, but how it is remembered, and what this living memory tells us about the present.

If the archive of Vodou songs conveys living history, then I wish to suggest that Haitian art practices a visual language in which questions of history and memory are conflated as living history. This is not only a distinctive art practice but one which produces an aesthetic form. Perhaps no current Haitian artist better illustrates this than Edouard Duval-Carrié.

History, Portraiture and the Language of the Visual

We are aware that the history of Haitian art is a long one. The art historian Carlo Celius, drawing on the early written histories of Haiti, notes that some of the early historical writings about Haiti speak of religious art existing in caves. He writes there were in caves "figures of various Zemes . . . cut in rock."[15] These figures seem to be of Taíno origin. He also makes the point that there is evidence that the early African slaves made figurative representations often in opposition to many planters' wishes. By the eighteenth century, portraiture was a growing art form in the colony of Ste. Domingue which continued to grow after the revolution. When Henri Christophe established the school of drawing at Sans Souci, he employed the English portrait painter Richard Evans to be its head in 1814.

In the nineteenth century, portraiture as a figurative form of representation had become one in which powerful individuals were celebrated. It was the same in Haiti, and some of the most important paintings of the period were the ones executed by Evans of Christophe and his son Prince Victor. As portraiture became a firmly established genre of Haitian painting, early paintings focused on famous personalities like the niece of Toussaint L'Ouverture, Louise Chancy

14 Benjamin Hebblethwaite, *Vodou Songs in Haitian Creole and English* (Philadelphia, PA: Temple University Press, 2012), p. 49.

15 Carlo Celius, "The Historical Art Traditions of Haiti" in Anthony Bogues (ed.), *From Revolution in the Tropics to Imagined Landscapes: The Art of Edouard Duval-Carrié* (Miami, FL: Perez Art Museum, 2014), p. 12.

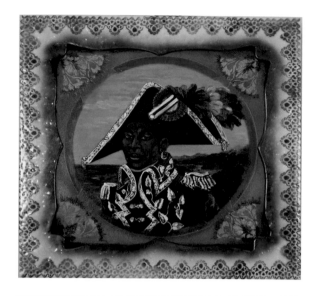

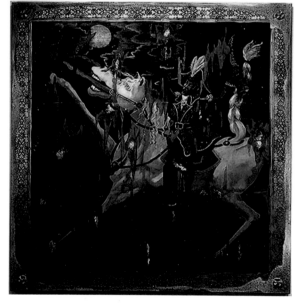

L'Ouverture. Portraiture continued to be popular well into the early twentieth century. In 1906, an advertisement published in a journal stated, "Should you want a beautiful crayon portrait that will last and reproduce exactly your features, contact Fernand Stines in his studio, rue Pavée."[16] Here the desire was for likeness, for mirror representations and a form of figurative realism. However this kind of figurative realism collapses when the portrait is of a figure who begins to transcend both space and time, becoming an overarching representative figure who can be deployed in ways in which his/her presence is not only central to the historical events in which he/she emerges, but is an active presence in the moment.

One such figure in Haitian history is of course Toussaint L'Ouverture. Painted over and over again in different ways, there are now countless images of him. After his death in a French prison in 1804, Toussaint L'Ouverture became an abstract figure who led the only successful slave revolution in the modern world. "Abstract" because he could be invested with many different significances. He was not a mythical figure because there was no attempt to naturalize him, rather he could be deployed as the most pristine sign of the revolution. During Toussaint's life, there were numerous images made of him, but what did the real Toussaint look like? In such a context, a historical figure takes on a new imaginary. He becomes representative of the nation or the event at its most pristine. Each generation of artists produces a new Toussaint, creating the ground for art and history to mix in the creation of an alchemy of images.

Edouard Duval-Carrié has been preoccupied with Toussaint. Like many Haitians, for him the determining event in Haiti was the Haitian Revolution and the protean figure of the revolution was Toussaint L'Overture. Between 2007-14, Edouard Duval-Carrié created a series that focused on images of Toussaint. In 2014, that series culminated in an exhibition, *The Many Faces of Toussaint L'Ouverture and the Haitian Revolution*.

Toussaint in Blue is the imagined portrait of the revolutionary no longer in battle. Dressed as a general, he is seen here as the master of all which surrounds him. The background of blue sky above the green land makes it clear that this is the Caribbean / Haiti. There is a calmness about the image. To my mind the artist here wants to depict this revolutionary slave leader as a Black Jacobin as he plays around with the red, white, and blue of the tricolor.

▲[top] Edouard Duval-Carrié, *Toussiant in Blue*, 2014, CSSJ Art Collection, Brown University.

▲[bottom] Edouard Duval-Carrié, *The Fallen Hero*, 2000.

16 Cited in Gerald Alexis, *Peintres Haitiens* (Paris: Editions Cercle d'Art, 2000), p. 24.

There is a magisterial feeling about the painting, of a figure with dignity and assurance as he looks back at the viewer. Contrast this with an earlier painting done in 2000, *The Fallen Hero*.

Here Toussaint is in pain. It is pain for Haiti. Known as a superb horseman, his horse is unsteady with one hoof off the ground and the other missing. This three-legged depiction represents chaos, and the green paint scattered all over the painting deepens our sense of chaos. Toussaint is barefooted. His attire is not a general's colors and his face carries, in part, traces of previous self-portraits of the artist. This is both the artist and Toussaint in pain and the fall is not a historical one, but rather one which suggests that the current politics of Haiti have lost the moorings established by the politics of Toussaint. The painting is presented five years after various reports about extensive human rights abuses and political turmoil. In 2004, as well, the UN Stabilization Mission was established. Haiti, the vanguard of the slave revolution which shook the system of racial slavery in the Western world, was now politically unstable. *The Fallen Hero* is not just about Toussaint and the evacuation of his memory; it was also about Haiti itself. The country in the grip of political instability had lost its original moorings.

It is clear in these two paintings that Duval-Carrié is deploying the Haitian genre of portraiture to tell a present-day story about Haiti. By 2014, Toussaint had become once again a figure of hope for the artist. Or put another way, Toussaint as a source for Duval-Carrié is the continued well spring of hope for Haiti. The artist seems to be asking us to think how we can live today with Toussaint's commitments to the possibilities of a country free from slavery.

One of the artist's most explicit and remarkable undertakings about history and memory is his *Memoire sans Histoire* [see page 34] (2009). A large (208 x 94 inches) six piece mixed-media work on aluminum, *Memoire sans Histoire* is a narrative of Haitian history. Reading from top left downwards and then across, we observe that in the top left are palm trees depicting the early conception of the island as a place of flora and fauna.[17] The eyes of the figure in the image is either that of a slave or of an indigenous person, and this can be read as the artist illustrating the emergence of the colony of Ste. Domingue. This setting is then disrupted by the Haitian military that surrounds the figure whom we should read as a dictator. Inserted in the image are red circles which one could interpret as parasitic insects creating trouble and bringing death. It is clear that this image is not only about the historical role of the Haitian military, but that the figure in the middle represents both a dictator as well as the paramilitary force of the Duvalier dictatorship, the Tonton Macoute. Reading across, there is the *lwa* of the sea, La Sirene, who seems to be holding up her hands in despair as fire painted in dotted lines burns a

17 The artist would return to the issue of European colonial fantasies of the region and the place of the flora and fauna within that colonial fantasy in his 2014 exhibition *Imagined Landscapes*, held at the Perez Museum in Miami.

building. However, it is not just La Sirene who is in despair, but the conditions drive the other *Iwas* to travel and they and some humans now move across the sea. At the back of the boat, standing up, and therefore the most prominent of the *Iwas*, is Ezili. There are in the Vodou universe at least six Ezili. My own reading of this figure is that she is Ezili Mapyang who is the *Iwa* of protection.

One current of Haitian art always has the *Iwas* traveling, and in the work of Duval-Carrié, because the gods are always amongst the people, they travel as well. In his work on slavery and the slave trade, they travel to the Caribbean, and now in the early twenty-first century, they migrate to America with Haitians. In the top right hand quadrant, the *Iwas* are still traveling, this time accompanied by the *Iwa* Dambala. This *Iwa* is associated with snakes, and circles the world, hence the way in which the artist paints the inside of the frame in the round and the half circle position of the snake. In the final bottom right is the figure of Toussaint. On his horse who is four-legged this time, the revolutionary leader is fighting. With sword in hand he is fighting parasites and obviously the military and dictators. This mixed-media project of the artist tells us a specific narrative about Haitian history. Beginning with colonial capture, the nation is now overtaken by a parasitic group of humans who bring death. The story skips over the ways in which the ex-slaves attempted to create a counter-plantation, but the point here is not historical chronology, rather it is to force the viewer to see a set of disruptive features in the history of Haiti. It is to suggest that there is a memory of the revolution, but no history, since there seem to be no traces, and even the *Iwas* have to leave. To return for a moment to the Vodou song, "The Battle Continues," there is a verse which says:

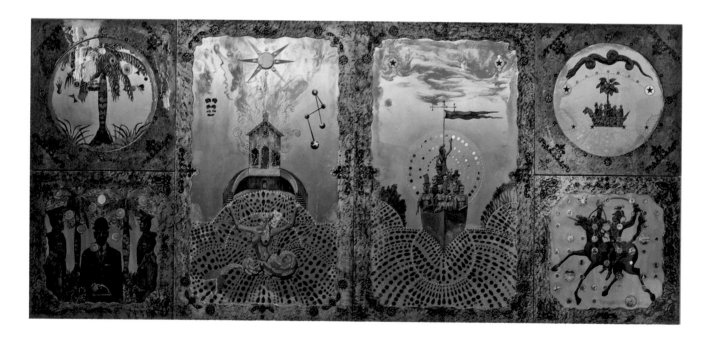

*Duvalier said he was of the people
He said he was Vodou; he did three harvests
He massacred our pigs
He sold the country for pennies on the dollar*

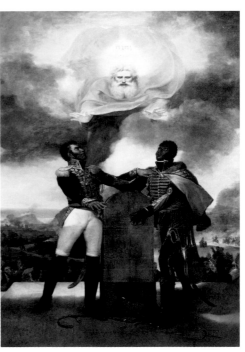

Duvalier is understood as a disruption within the history of Haiti. It does not mean that there were no other military regimes, but the Duvalier regime developed and honed a deadly paramilitary force in which death was the governing order of the regime. So empty is memory in this painting that when the *lwas* leave Haiti the artist makes it clear that they do so searching for somewhere else. In the end, the epic figure of Toussaint returns, but this time to fight a new fight.

Among the questions that the work poses is what kind of memory can the ordinary Haitian have? How does a collective memory of a revolution collapse into the activities of deadly dictatorship which then beckons for the return of the epic figure of the revolution to begin a new struggle? In this piece, the artist seems to be saying that to have memory without history is a dangerous business. Yet, paradoxically, in this piece, the figure of Toussaint is both memory and history.

Taking his cue from the ways in which Haitian artists conceptualize their art as history, Duval-Carrié raises a set of critical questions about art and memory. In doing so, he has taken the specific current in Haitian thought and culture which sees the function of Haitian art as telling the history of the island. Here, one might recall that the artist Philome Obin made it clear that his work was to, in his words, "leave documents for future generations that writing alone could not provide." As well, Andre Pierre wanted to paint the history of the *lwas* and their presence in Haiti. Duval-Carrié, like them, is concerned with history, but for him it is about illuminating the present. His engagement with history is therefore as a form of historical critique: it is why his historical work can be called *living history*.

We need to make clear that one is not suggesting that Duval-Carrié is a historical painter operating within the conventional genre of historical paintings. Linked to European academic institutions when it emerged, this genre was often about the legitimization of state rule. There were, of course, some instances when historical painting was not used to celebrate power, but to represent something new. In this regard the *Oath of the Ancestors* (1822), by Guillaume Guillon-Lethière, to commemorate the 1802 pact between Alexandre Petition and Jean-Jacques Dessalines in the revolutionary struggle of the ex-slaves of Ste. Domingue against French colonialism, stands out.[18] What I want to suggest is that for Duval-Carrié, history is a starting point for

▲Guillaume Guillon-Lethière, *Le Serment des Ancêtres* (*Oath of the Ancestors*), 1822, oil on canvas, 400 x 300 centimeters. Haiti, Port-au-Prince, Musée National. Public domain.

◄[facing page] Edouard Duval-Carrié, *Memoire sans Histoire*, 2009, mixed media on aluminum, 94 x 208 inches. Collection of Serge and Johanna Coles.

18 For a very good discussion of this painting and its origins, see Helen Weston, *"The Oath of the Ancestors* by Lethiere 'le mulatre: celebrating the black/mulatto alliance in Haiti's struggle for independence," in Geoff Quilley and Kay Dian Kriz (eds.), *An Economy of Color: Visual Culture and the Atlantic World*, 1660 -1830 (Manchester, UK: Manchester University Press, 2003), pp. 176-196.

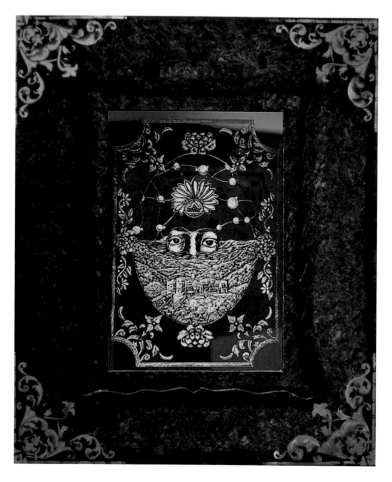

critique, that his historical portraits are not about legitimation nor commemoration, but seek to create dissonance and critique of the present, Duval-Carrié works through history, making it a part of the present. He creates a visual historical vocabulary in which history is embedded within a current conjuncture. This process can be discerned in his recent series, *The Kingdom of This World*.

Historical Novel and Art

The Kingdom of This World remains one of the classic novels about the Haitian Revolution. Written by the Cuban novelist Alejo Carpentier, and first published in 1949, the novel, through the eyes of Ti Noël, tells the story of the Ste. Domingue slave revolution and the first years of the independent black state of Haiti. Through Ti Noël's eyes, it narrates moments before the slave revolution and the figure of Makandal, the revolutionary slave who engages in a campaign of poisoning members of the planter class before he is captured. Makandal is a special figure within the novel both because he is memory of the revolution that had not yet been in state power, and because as a houngan (a vodou priest), he had a special relationship to the *lwas*.[19] The novel moves from the revolution to the building of the Citadel at Sans Souci. The methods used by Henri Christophe to build the Citadel ran counter to the aspiration of the ex-slaves, even if it was done to defend the revolution. For Ti Noël there was something not quite right. We read in one passage of the novel, "A heavy blow landed across the old man's back . . . Ti Noël began to shout that he was personally acquainted with Henri Christophe . . . but nobody paid any attention to him."[20]

The novel ends with the killing of Christophe, and Ti Noël "hurling his declaration of war against the new masters."[21] He, of course, like Makandal, disappears and the author leaves us with the images of another transformation and with words invoking the beginning of the revolution and the ceremony of

▲Edouard Duval-Carrié, *The Kingdom of This World*, 2017, engraving on Plexiglas, 31 x 27 inches.

19 Important to note that Makandal features as a figure who has often been painted. In the oral tradition which surrounds him, after he is captured and put to death by fire, he jumps out of the flames and is never seen again. The story is that he transforms himself into various animals.

20 *Kingdom of this World* (New York, NY: Farrar, Straus & Giroux, 2006), p. 110.

21 Ibid, p. 179.

Bois Kayiman. The novel concludes with Ti Noël "drying himself in the sun, a cross of feathers which finally folded itself up and flew off into the thick shade of Bois Caiman."[22]

Duval-Carrié has read this novel over and over again. He states in an interview, "So it's a book that I read early on in my life and to me it is the most beautiful story ever written about Haiti."[23] Duval-Carrié's attempts to tell the story of the novel is dominated by the figures of Ti Noël and Makandal and represents his most recent effort to tell the story of the slave revolution in Ste. Domingue. It is not a precise chapter by chapter illustration of the novel, but rather a carefully thematic visual rendering. Critical to this rendering is the process of metamorphosis which both Ti Noël and Makandal undergo. In this series the artist, intrigued by the transformation of humans into animals, a constant feature of his work, allows the characters to make other transformations. This is part of the aesthetic in which he operates, one which, in large measure, depends upon forms of composition where things are juxtaposed and become something else. There is always in his major works a feeling of assemblage. I would suggest that this penchant for compositional juxtaposition is facilitated by his method of working through living history, since the method oftentimes demands the jostling of objects and images of different temporal provenance.

It should also be of interest that Duval-Carrié finds rich sources for his work in this novel. This is not a historical novel in the common literary sense. As a novel, it was done in a literary style that Carpentier himself called "the marvelous real." Visiting Haiti in 1940, he noted that he "discovered" the "marvelous in the real." Later on in 1956 at the first Black Writers and Artists conference in Paris, the Haitian intellectual Jacques Alexis, in addressing the art of Haiti, noted that the aesthetic which was being produced was a "marvelous realism." I have argued that this is a specific genre of Haitian art which describes a school of art in the twentieth century.[24] Given this, one question we are faced with is how can we describe the aesthetic practices of Edouard Duval-Carrié as he engages with history as critique? I suggest that Duval-Carrié has extended the boundaries of "marvelous realism," and that he has done this in the following ways.

If we say that twentieth-century Haitian art emerges alongside the growth and the preoccupations of the indigenist movement in Haiti,[25] and we can agree that the aesthetic frame is "marvelous realism," then we can begin to tell a different story of Haitian art which does not gesture either towards

22 Ibid, p. 180.

23 Edouard Duval-Carrié, "Repossessing the Old and Creating the New" in Anthony Bogues (ed.), *Metamorphosis: The Conjunctural Art of Edouard Duval-Carrié* (Miami, FL: MOCA, 2017), p. 10.

24 See in Anthony Bogues, "Loas, History and Aesthetic of the Popular: Reframing Haitian Art" in *Haiti Deux siècles de creation artistique* (Paris: Grand Palais, 2014), pp. 36-40.

25 The critical text of course for this is Jean Price Mars, *So Spoke Uncle* (1928). Within the domain of art, the work was crucial. For a discussion of all of this, see Michel Philippe Lerebours, "The Indigenist Revolt , Haitian Art, 1927-1944," in *Callaloo* 15.3 (Baltimore, MD: John Hopkins University Press), pp. 711-725.

surrealism or the so-called naive. It also means that aesthetic innovations can now be considered within this specific tradition. It is from this stance that I suggest that Duval-Carrié, in his art practice of historical critique, engages a form of realism in which the fantastic dominates the canvas or the installation. The movement from *Memoire sans Histoire* (2009) to *Kingdom of this World* (2017) is one in which the process of metamorphosis becomes critical to the story. One critical phase within this journey was the artist's exhibition *Imagined Landscapes* (2014). Today I would argue that we are now at a new stage in this artist's oeuvre.

Some concluding thoughts

From his 1989 show in Paris, *La Revolution Française sous les Tropiques*, I suggest that Edouard Duval-Carrié in his artistic work took a distinctive historical turn. In an interview about his preparation for the show he stated, "They provided me with an excellent historian who gave lessons on Haitian history . . . I had access to first-hand accounts of events at the time . . . it was a moving experience."[26] Duval-Carrié has always been preoccupied with the historical archive and he spends a great deal of time in historical research before making his art. This preoccupation might push us to see him as primarily a visual historian of the region. However, to see him only as this would, miss the sharp, critical edge of his work as a critic. Thus, for example, one could just see his recent work, *Of Cotton, Gunboats and Petticoats*, and think that this is only a historical painting of the US intervention in Haiti during the early twentieth century. It is much more than a critique of that invasion and of US intervention, in general, within the Caribbean and Latin America, as the cotton bolls evoke the history of slavery.

Even what might seem to be an exhibition without critique, *Imagined Landscapes*, is an exhibition primarily considered as a criticism of the Hudson River school of landscape painting, and has a sharp critique running through it not only of the early colonial so-called "explorers," but of the ways in which imperial power continues to dominate the region. This critique runs through the lush glittering landscapes that he paints.

In visual culture, we often think about the ways in which the visual imagery shapes the writing of history. In this perspective, the visual is considered an aid to historical knowledge. The art of Edouard Duval-Carrié is distinctive. It is not an adjunct to history, instead, it is living history itself, critiquing our present. For Duval-Carrié art is a medium of criticism and history is a source for making that kind of art.

—*Anthony Bogues*

▶[facing page] Edouard Duval-Carrié, *Of Cotton, Gunboats and Petticoats*, 2017, mixed media on aluminum artist's frame, 72 x 60 inches. Image courtesy of the artist.

26 Edouard Duval-Carrié Interview," Art History and the Politics of the Imagination" in *From Revolution in the Tropics to Imagined Landscapes: The Art of Edouard Duval-Carrié*, p. 31.

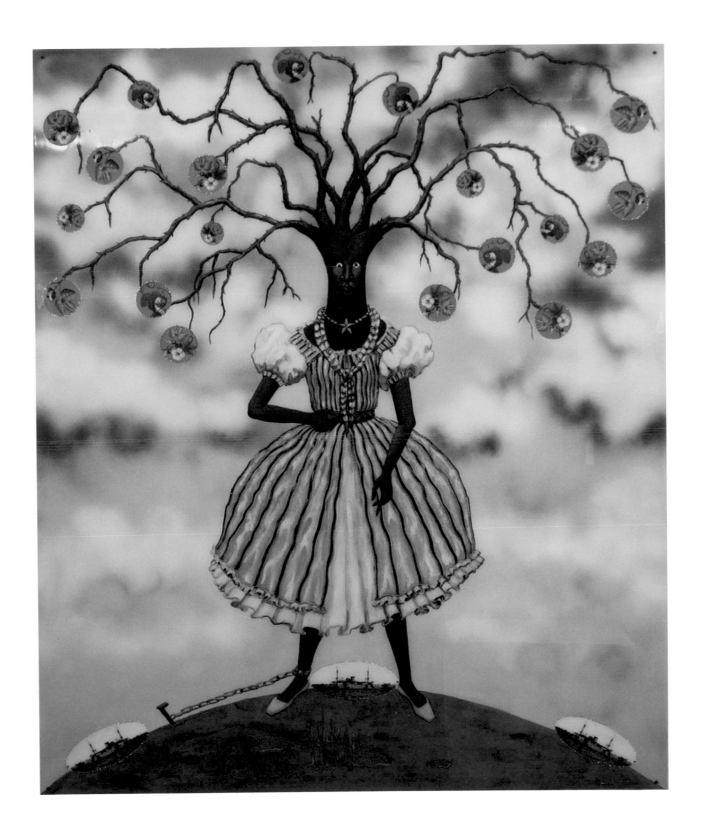

Edgy Edouard

Martin Munro

The first time I met Edouard Duval-Carrié, he said something that has since stayed with me. It was in 2007, in Trinidad, where he was participating in a conference I co-organized on contemporary Haitian art and literature. We were having lunch, and talking about his relationship with the other, mostly younger, artists who were participating in the event. He hesitated a moment, gave a smile, and with a little wave of his hand, indicated that they did not think much of his work. I expressed my surprise, and asked why that was, to which he replied "Oh, they don't think I'm edgy enough." The phrase struck me, and is in the back of my mind each time I see some of his work: what did they mean? What did it mean to him? What did they mean by 'edgy'? And were they right?

I think what they meant is simple, in a sense: that Edouard's work is, relatively speaking, more accessible, more inviting, more aesthetically pleasing than that of most other contemporary Haitian artists. I remember a phrase uttered to me by an arty, hippyish older student by way of a withering critique of a terrible piece of work I had produced in a high-school art class: "It's a bit harsh on the eyes, man." Edouard's work, by contrast, is rarely harsh on the eyes, even when the subject is challenging—murder, incarceration, exile, natural disaster. Perhaps the other artists meant that his work, and his aesthetic sensibility, "take the edge" of such experiences, recuperate them in a sense, beautify them, and make them more palatable to consumers of his art?

Such an interpretation is nevertheless interesting in that it allows the possibility that the sharp edges of experience remain present in the work, or that they inform it in some way, and that perhaps they manifest themselves in ways different from more deliberately challenging or jarring forms. This is the possibility that I will consider for the rest of this essay: in what senses might Edouard Duval-Carrié's work actually be considered "edgy"?

In its verbal sense, the word edgy means "to give an edge to," which may be taken literally or figuratively. In the literal meaning, it could be said that Edouard's work is indeed edgy, in that many of his paintings in particular have edges, borders, and frames made by the artist. This may suggest a desire to tidy things up, beautify, and close off the work and its potential meanings. It may also however suggest that certain works are acts of memory that need to be contained, framed, and controlled. For example, the painting, *Mardigras au Fort Dimanche* (1992/1993) is a form of family portrait of the Duvaliers in

the notorious prison where many of their opponents met their demise. They are painted within a prison cell, and that space of confinement is reinforced in a way by the dark-colored frame that suggests that this memory and all it represents needs to be kept at bay, enclosed, and that memory itself can be a form of prison, made up of many such smaller cells that only occasionally are realized in visual form. The presence of the frame does not so much "take the edge" from the memory as indicate that the image itself and the traumatic memories it evokes contain sharp mnemonic edges that even now are rarely exposed so directly and powerfully in Haitian art.

Other historical works, such as *Roman Noir à Saint-Domingue* project further back in time and are framed, again in a way that suggests something of the need to control the memory it represents. This is another form of portrait, in this case of plantation society, and the radically divided "family" it brings into being: the *Grand Blanc*; the *Petit Blanc*; the *Mulatresse*; and the *Négresse*. The antique-style gold-colored frame forms part of the painting's parodic edge—the portrayal of the whites as, in turn, proud and vain, yet lame in a sense with the presence of the walking stick, and ridiculously small yet violent, liable to use the whip at any moment. The mulatto woman is the literal creation of the white man and the black woman, a being on the edge of whiteness and blackness who in this case is related to the white woman, whose picture hangs in another frame—a kind of medallion portrait hung with a fancy bow. The white woman's absence suggests something of her lack of influence in the power play that the painting represents, and which is suggested in the square tiles that appear as squares on a chessboard, framing and yet also enabling and situating the position of each character. It is perhaps significant in this regard that while the two women's feet overflow the edges of their squares, the two white men are largely confined to one. Also, they look directly ahead, from the front of the scene, while the two women look at them, as if they are in control, or at least have a broader perspective on the power game of which they are part. The doorways are further framing devices that add depth and multiply the edges that constitute in large part the work and its meanings. The rather sterile room in which the human figures are framed contrasts with the blues and greens of the outside world, the natural sphere from which the people seem separated, as if their power games go against nature and the natural order of things. The distant hills form their own kind of frames—natural, irregular, undulating, and free, as opposed to the strict squares and rectangles of the colonial frames that create and express the atmospheric edginess of the piece—the palpable tension between the characters, and the feeling that those tensions are the rough edges that cannot finally be controlled by any frame.

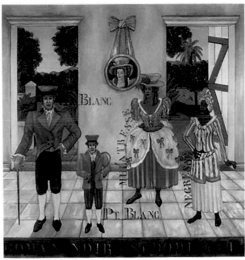

In other instances, frames are incomplete or broken, and the edges blurred or indistinct. The mixed-media work *My Life as a Tree* (2010), for example, explores the repeated motif of the artist's life as an arboreal phenomenon,

▲[top] Edouard Duval-Carrié, *Mardigras au Fort Dimanche*, 1992-1993, oil on canvas, 59 x 59 inches.

▲[bottom] Edouard Duval-Carrié, *Roman Noir à Saint Domingue*, 2002. Image courtesy of the artist.

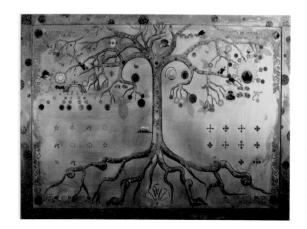

its roots exposed and its branches shooting in unpredictable directions. The work is framed only in the four corners; in each of these the frame ends rather abruptly, as if broken, and contrasts with the all-consuming deep black that appears like the darkness of the night, and against which the intricate gold-colored details stand like stars or illuminations. These, in turn, may be seen as points of memory like the small house motif in the left hand corner, a place of home and belonging that seems far back in time and space and whose regular, orderly sides and frames contrast with the spiraling forms on the upper right, and indeed the tentacular spread of the tree branches. The suggestion is that the artist's life is a sort of open frame, a journey through and on the edges of darkness and light.

Apart from the literal ways in which Duval-Carrié "gives an edge" to his work, there are figurative, symbolic ways in which edges and borders are explored and represented. Indeed, one might say that the thematic core of his entire work is related to a set of borders and edges, margins, points of crossing, and thresholds. There is, for example, an extended and recurring play between subject and object, work and life, so that one wonders whether the work is a reflection and actualization of the life, or conversely, whether the life is an extension of the work. Where does the work begin and the life end? Of course, there is no clearly defined edge that separates the two, and no preconceived understanding of time, being, and memory that informs the work: this is created with and in the work in a way that effectively dismantles any notion of a distinct border between

▲Edouard Duval-Carrié, *My Life as a Tree*, 2010, mixed media in artist's frame, 47 x 67 inches. Image courtesy of the artist.

▶Edouard Duval-Carrié, *My Life as a Tree #3*, 2010-2014, mixed media in artist's frame, 44 x 63 inches. Image courtesy of the artist.

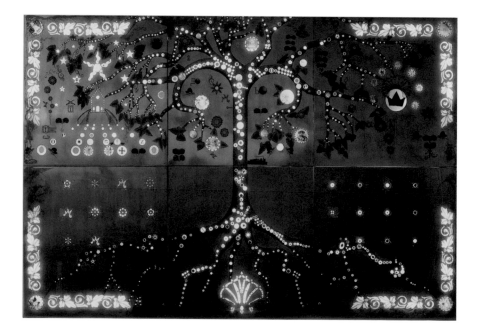

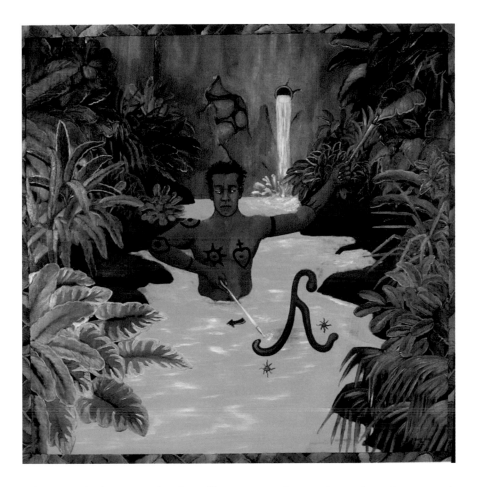

subject and object. Evidently, self-representative works such as *Autoportrait* (1994) play on this blurred distinction, on the edge between subject and object, as the artist's image of himself appears semi-submerged in water with what appear to be paintbrushes in his hand, working, painting the image as it takes form. The wall that serves as the background seems to block out the temporal backdrop, though imperfectly, since there is a pipe through which water falls, and there are serious cracks in the wall that suggest the force behind it will eventually prevail and break it. The image of the artist is placed, significantly, in the water, between two banks that overflow with vegetation so that one feels there is no space on the land for him, and that he must remain between the two sides, in the water, which has its own dangers. These perils are suggested in the image of the snake that is about to enter it and that itself crosses the edge between land and water, and, it seems, between past and present.

Just as the works often sit on the edge between past and present, so they also exist spatially in indeterminate, in-between spaces. This is especially true of the works that engage most directly with issues of migration, a

▲Edouard Duval-Carrié, *Autoportrait*, 1994, oil on canvas in artist's frame, 66 x 66 inches. Image courtesy of the artist.

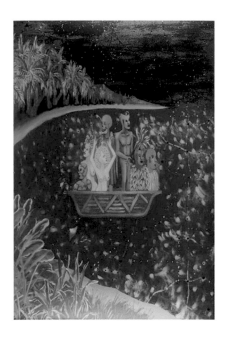

striking example of which are the central pieces of the illuminated mural, *Indigo Room* (2004). These pieces form a triptych that plays out in symbolic form the experience of migration for the Haitian gods that are presented at first just off the shores of Haiti, a liminal space, in itself, marked out by the curved shape of the shoreline. The migration takes place at night, as if to suggest the gods travel in darkness, in dreams, and in the unconscious. The central piece situates the gods at sea, in between departure and arrival, in a kind of repetition of the Middle Passage, only now their destination is the United States, whose presence is indicated in this middle work by the almost spectral figure of the warship that seems to be bearing down on the little boat that carries the gods. The third image shows the gods arriving at Miami Beach, on the edge of their new place and their new existence in the hypermodern US city, whose bright lights and tall buildings are placed themselves at the edge of the land. This suggests that life in America exists always on edges and frontiers, boundaries that the gods can cross only by night, in darkness, and in the imagination, which appears as one of the few spaces in which such migrations can be fully realized.

The images further show how Duval-Carrié works often on the edge between the divine and the human, the sacred and the profane. The gods are everyday, they seem troubled by worldly issues, forced to migrate like their human counterparts. The images also play on possibly the most important dichotomy with which the artist contends: that between home and not-home, Haiti and the US. An exile since a young age when his family fled the Duvalier regime, Duval-Carrié paints Haiti with the love and tenderness of an émigré, though never with sentimentality and always with an awareness of the political stakes. Often, his painterly perspective is from the outside, as if he is an observer looking in

▲Edouard Duval-Carrié, central triptych of *The Indigo Room, or Is Memory Water Soluble?*, 2004, mixed media on Plexiglas and cast acrylic with assorted objects. NSU Art Museum, Fort Lauderdale, Florida. Image courtesy of the artist.

on a place he has left behind, such as in *Autoportrait* above, which gives the impression that he is looking at a version of himself that he has left behind, and that his being and identity are split between different places and times. A striking example of this external, observational perspective is the work *Le Baron Triomphant* (2011), a mixed-media representation of the god of death overlooking post-earthquake Port-au-Prince, his bony hand raised like a victory salute. The visual perspective is from the rear, as if the artist is destined never to be *in situ*, always to be off center, behind, on the edge.

In all of these works, even in those that deal with the most troubling aspects of history, politics, and personal experience, there is always beauty, an unfaltering taste and a reaching for the sublime. Perhaps this is what some of his fellow artists find to be safe or unchallenging in his work, but in his unremitting exploration of and adherence to beauty, Duval-Carrié shows that it does not at all act to smooth the edges of history or personal experience. Rather, beauty and suffering are not antinomical: the edge is in the beauty, the beauty is the edge, and the work is throughout sharp, thorny, and, yes, unfailingly edgy.

—*Martin Munro*

◄Edouard Duval-Carrié, *Le Baron Triomphant*, 2011, mixed media on acrylic, total dimensions 72 x 72 inches, 9 individual panels 24 x 24 inches each. Image courtesy of the artist.

Close Encounters with Edouard Duval-Carrié:
A Quarter Century of Friendship and Collaboration

Edward J. Sullivan

Introduction

It is a privilege to be able to contribute to the series of essays within this catalogue of the work of Edouard Duval-Carrié organized by the Florida State University Museum of Fine Arts. As a historian of the modern and contemporary arts of the Caribbean and Latin America, I have charted Edouard's career since the late 1980s, when his paintings, multi-media pieces and sculptures first captured my attention. In addition, the artist and I have developed a close personal and professional relationship that has lasted over a quarter century (thus the title of this essay). Perhaps unlike other texts I have written about Edouard over the years, which have attempted to present a scholarly panorama of whatever phase of his art I had chosen to analyze, I would like this piece of writing to be an homage to an artist whom I consider one of the most provocative, socially-engaged and thoughtful practitioners of Caribbean visuality at the current moment. At its heart, however, I would like this contribution to the FSU Museum's catalogue to be a testimony to many years of collaboration and friendship.

The fact that this exhibition takes place at a major university is also appropriate. Edouard has been deeply engaged throughout the past several decades with projects that have borne fruit not only as manifestations of his artistic imagination but as tools for instruction and commentary upon the realities of social movements, political and economic circumstances and, most importantly, implements for instruction and advancement of learning for students of all ages, ethnicities, social classes and ideological persuasions. Duval-Carrié has played an important role in many colleges and universities throughout the United States as participant in workshops, residencies and student-organized activities that have served to highlight the significance of Caribbean, and especially Haitian culture. His presence at both prestigious institutions of higher learning, as well as the elementary and secondary schools where he works throughout his adopted hometown of Miami (especially in the district of Little Haiti, but also beyond), has been instrumental in bringing to the consciousness of a broad swath of the public an understanding of Haitian culture in all its forms, from art, to music, food or the oral traditions of poetry and storytelling, among many other things.

As founder and principal supporter of the Haitian Cultural Arts Alliance, an impressive exhibition and performance space that is located literally in the

▶[facing page] Film still, *Winthrop-King Interview with Edouard Duval-Carrié*, conducted by Chelsea Elzinga with assistance from Ryan Augustyniak, January 25, 2017, Winthrop-King Institute for Contemporary French and Francophone Studies, Florida State University, Tallahassee, Florida.

artist's backyard (adjacent to his Miami studio), Duval-Carrié has acted not only as an ambassador for Haitian culture in the United States, but as a social activist in the most literal of terms, by placing Haitian art, language (Kréyol and French), sounds and smells directly within the urban fabric of the most prominent cultural mecca of the state of Florida. Among the most impressive undertakings Edouard has accomplished within the realm of activities of the Haitian Cultural Arts Alliance is the series of exhibitions known as the *Global Caribbean*. This is an ongoing project to investigate and expose the most forward-looking artists of the region to wider global scrutiny. The exhibitions, including work from the many cultural spheres that comprise this aqueous continent known as "The Caribbean" have been sent to other institutions outside Miami and have served a crucial role in establishing the region as a focal point of cultural achievement in the twenty-first century. Duval-Carrié has had a parallel career as exhibition curator, and I will comment on this aspect of his creative personality below; but I wish to highlight his enthusiasm, activism and dedication to political and artistic awareness of Haiti and beyond as a central element in his multifarious achievement throughout his long career. Now, at the mid-point of his creativity, he is willing to branch out even further in his engagement with the public, students, and enter into more extensive dialogues about inclusiveness and acceptance of all ethnicities, the social standing of people of color, the significance of the diasporic and immigrant experiences in both the United States and beyond. At a moment of political

uncertainty, dilemma and traumatic self-questioning in which the world finds itself in the second decade of the century, Edouard's activities are doubly necessary and doubly appreciated.

First Acquaintance

My friendship and my numerous collaborative projects with Edouard Duval-Carrié began in 1992 in Mexico. For a number of years there had been an ambitious project evolving in Monterrey (state of Nuevo León, an industrial city with many cultural and financial ties to the United States). A new contemporary art museum was constructed over a period of several years. Called the Museo de Arte Contemporáneo de Monterrey (MARCO), the building was designed by Ricardo Legorreta, the Premium Imperiale prize-winning architect who was responsible for some of the most forward-looking structures (domestic, civic and corporate) in Mexico, the US and throughout the world since the death of his colleague and mentor Luis Barragán.

For a number of years, I had served as a member of the museum's art advisory board that was partly responsible for suggesting exhibitions as well as acquisitions through the prestigious *Premio MARCO* that provided substantial amounts of money for the winners, and the acquisition of works submitted for the permanent collection. The inaugural show of what came to be one of the most active international contemporary art spaces in the western hemisphere through the 1990s and into the early 2000s (it is still very much in existence but with a somewhat more limited exhibition profile) was conceived as a major survey of artists throughout the Americas during the 1980s. *Mito y Mágia en las Américas: Los Ochenta* (Myth and Magic in the Americas: the Eighties) was as eye opening and controversial as the immense museum in which it was installed in June 1992. Much of the art exhibited represented various permutations of Neo Expressionism. On the cover of MARCO's catalogue there appeared, presciently (given the great deal of current interest in this painter's work), a characteristically bold painting of a skull by the Haitian-Puerto Rican painter Jean Michel Basquiat. Included in the show were dozens of artists who represented the wide spectrum of tendencies of painting from the decade. Basquiat's fellow Haitian artist Edouard Duval-Carrié was one of the outstanding presences in "Myth and Magic" with several of his characteristic canvases in which the *lwas* (gods or spirits) of Haitian vodou appeared and energized their space in this Mexican context.

Having written one of the essays for the catalogue of the MARCO exhibition, I was well aware of the significance of Edouard's paintings and was impressed by how they took over and literally "owned" the space in which they were exhibited. While not my first acquaintance with his art, seeing Edouard's work in this trans-national context brought home for me both their singularity as well as their overlapping correspondences with the art of other painters of the time for whom bold statements, strong colors and, in many instances, a strong spiritual and psychological underpinnings

played a major role in their visual expression. I was, in addition, fascinated by the idea of looking at this Haitian artist's depictions of the various deities of vodou such as Erzulie Freda, Ogou, Dambala, Baron Samedi or Papa Legba within the context of a nation (Mexico) whose own art has been so deeply imbued with the spiritual heritage of both pre-Hispanic peoples and their beliefs and the syncretic overlays of Spanish Catholicism with its own highly dramatic iconography. This juxtaposition and dramatic contrast was not at all lost on my Mexican colleagues in Monterrey who chose to present one of the first retrospective shows of the art of Duval-Carrié. Organized by the Australian curator Charles Merewether, who had done considerable work with Mexican contemporary art, Duval-Carrie's solo exhibition (also in 1992) was an even more dramatic *mise-en scène* for the artist's intricate visual dramas in two and three-dimensions.

My first meeting with Edouard happened in 1992. It represented a turning point in my understanding of Haiti and Haitian art (even though I was not to travel to Haiti until 2007 on a memorable trip with the artist about which I will write briefly below). Our many conversations and encounters over the years have proven to be crucial for my deepening interest in Haiti and the greater Caribbean. His insights into travels (forced or self-determined), migrations and cultural assimilations or resistance, have inflected my consciousness both aesthetically and politically.

My own work has often concerned the concept of *mestizaje* or *métissage* (racial blending and mixing), reflecting the Cuban anthropologist Fernando Ortiz's theory of "transculturation" as regarding Latin American (especially Mexican) art. My contacts and what I (and, I believe, all of his audiences who are sensitive to such socio-cultural issues) have learned from Duval-Carrié's work is a deeper sensibility to the effects of crossing borders and the permutations of cultures and experiences that happen when we allow ourselves to examine the concatenations of events and consequences that come about with encounters with those whom we might consider "the other."

Mutual Projects

If I remember correctly, my first opportunity to write anything substantial about Edouard's work occurred in 1997 when I published an essay entitled "Sacred Migrations" for the catalogue of an exhibition of the artist's new works held at the Quintana Gallery in Miami. The art in that show continued to examine the ideas that had permeated Duval-Carrié's earlier projects, namely the encounters between the gods of the vodou pantheon in Haiti and beyond. Duval-Carrié was by that point constantly experimenting with new and sometimes experimental media that took his art well beyond the confines of conventional painting, creating worlds and environments in which the viewer could immerse herself in the colors, forms and lights of both mundane reality and its transformation when entering the netherworlds of spiritual imagination. Glass, resin and the manipulation of the lighting of Edouard's pieces became

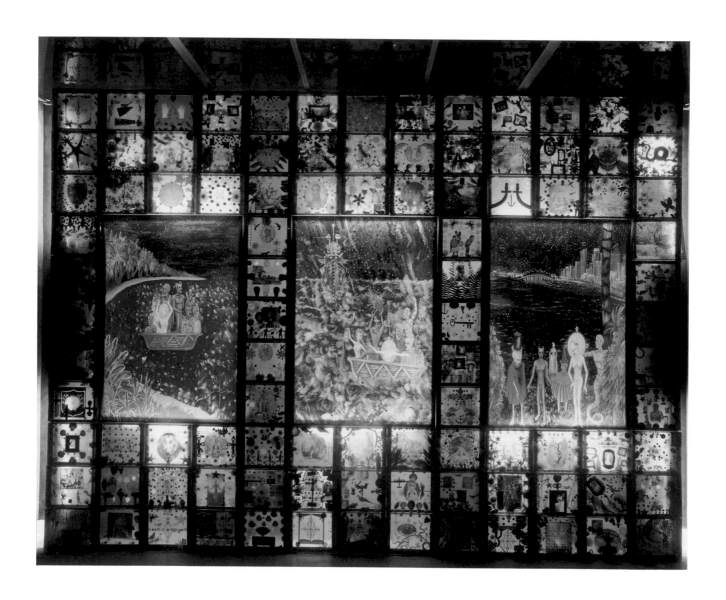

▲Edouard Duval-Carrié, *The Indigo Room, or Is Memory Water Soluble?*, 2004, mixed media on Plexiglas and cast acrylic with assorted objects. NSU Art Museum, Fort Lauderdale, Florida. Image courtesy of the artist.

increasingly important, as evidenced in many individual pieces as well as complex installations, such as his thought provoking *Indigo Room* created for the NSU Art Museum of Fort Lauderdale in 2013.

It is important to realize that Duval-Carrie's concerns are by no means completely within the territory of the ethereal or the dream-like domain of the gods. As recently as last year (2016), I was asked to write an essay for another exhibition by Edouard that took place at the Lyle O. Reitzel Gallery in Santo Domingo (Dominican Republic). The show's title "Hispaniola Saga" alluded to the politically charged nature of the art on view. There have been acute political and personal tensions between Haiti and the Dominican Republic for decades. The infamous saga of the massacre of hundreds of Haitian workers in the northern border area in October, 1937, has been recounted by many including the Dominican historian Bernardo Vega and the Haitian-American novelist Edwidge Danticat in her moving book *The Farming of Bones*.[1] The massacre was under orders from the Dominican dictator Rafael Leonidas Trujillo, who (although himself of Afro-Dominican heritage) wanted nothing more than to whiten his country with any means at his disposal including the frightful episode of inciting his army to murder men, women and children. Edouard's paintings on this theme have added to the debate itself as well as capturing in dramatic fashion the emblematic visualities of the as-yet-unsolved conflict. Writing my essay for that exhibition while in Paris in the winter of 2016, having had many conversations with Haitian émigré colleagues (and where, in 2014-15, there had been a major exhibition of Haitian art at the Grand Palais entitled *Haïti: Deux Siècles de Création Artistique* in which works by Edouard played a major role), I thought even more deeply than I might normally have done about the conundrum facing an artist given the self-appointed task of visualizing a severe societal trauma that has played a major part in Haitian national consciousness.[2]

A Major Retrospective Exhibition, Book And Travels To Haiti

The Figge Art Museum in Davenport, Iowa (formerly the Davenport Art Museum), is one of several institutions in the United States with major collections of Haitian art.[3] The museum has amassed a superb collection of works by the first generation of the so-called Haitian Renaissance artists begun by a local medical doctor, Walter E. Nieswanger, who first visited Haiti in 1961. Among the many artists represented are some of the most outstanding Haitian masters such as Hector Hyppolite, Wilson Bigaud and Rigaud Benoit. The

1 See Bernardo Vega, *Trujillo y Haití* (Santo Domingo: Fundación Cultural Dominicana, 1988) and Edwidge Danticat, *The Farming of Bones* (New York: Soho Press, 1998, reprinted 2013). A recent discussion of the events of 1937 appears in Joshua Jelly-Schapiro, *Island People. The Caribbean and the World* (New York: Alfred A. Knopf, 2016), pp. 198-225.

2 Régine Cuzin and Mireille Pérodin (eds.), *Haïti. Deux Siècles de Création Artistique* (Paris: Réunion des Musées Nationaux, 2012).

3 Among other museums with important Haitian holdings are the Milwaukee Art Museum, The Waterloo (Iowa) Center for the Arts and the Huntington Art Museum in West Virginia.

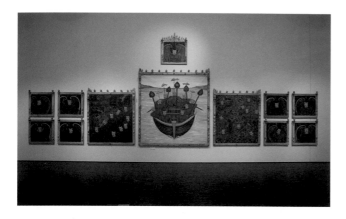

museum continues to collect in this area and Edouard Duval-Carrié's art figures prominently in its holdings. In 2006 curator Michelle Robinson mounted a major retrospective of Edouard's art. Entitled *Edouard Duval-Carrié: Migration of the Spirit*, the exhibition (that filled the ample galleries on the museum's main floor) was an arresting display, concentrating on a series of installation and painting projects and altars done since the late 1970s.[4] Most outstanding was the presence of some of Edouard's representative and well known works, such as the 1989 *Retable des Neuf Esclaves* (Altar to the Nine Slaves), the 1992 *La Destruction des Indes* (The Destruction of the Indies—whose title references the classic sixteenth century text by Dominican Friar Bartolomé de las Casas), the fifteen bronze busts comprising *The Vodou Pantheon* (1996), and many more individual images. A deep sense of social and historical critique characterized the show. The artist's classic image *Mardigras au Fort Dimanche* (1992-93) depicting the members of the notorious Duvalier family as black-dressed thugs and ominous court sycophants surrounding the diminutive figure of "Baby Doc," Jean Paul Duvalier (son of the dynasty's founder) dressed in a bridal gown and holding a pistol (image on page 41).

This exhibition (which opened on a cold and snowy mid-West night in the winter of 2006, creating a strong contrast with the warmth of the art inside the museum) marked a turning point in Edouard's career in the US. Its catalogue is an important tool for studies of the artist. It included an essay by Donald J. Cosentino, the near-legendary art historian and anthropologist who had included Edouard's work in his landmark exhibition *The Sacred Arts of Haitian Vodou* (seen at the Fowler Museum of Cultural History at UCLA in 1995). I had the pleasure of being asked to write the principal essay ("Edouard Duval-Carrié: Migratory Journeys of the Soul"), that placed his art within a larger context of Haitian as well as pan-Caribbean art over the last several decades. My work on this essay served as a catalyst for the discussions between Edouard and myself regarding a future major monograph of his art.

In 2007 *Continental Shifts: The Art of Edouard Duval-Carrié* was published. I served as editor as well as writer of the overview essay. Other authors included Donald J. Cosentino, Joel Weinstein, C. Herman Middelanis and Rachel Beauvoir-Dominique who contributed a fascinating analysis of the

▲Edouard Duval-Carrié, *Le Retable des Neufs Esclaves*, 1989, installation views from 2005, Figge Art Museum, Davenport, Iowa.

▶[facing page] Edouard Duval-Carrié, *La Destruction des Indes*, 1992, installation view from 2005, Figge Art Museum, Davenport, Iowa.

4 Michelle Robinson, *Edouard Duval-Carrié. Migrations of the Spirit* (Davenport: Figge Art Museum, 2006).

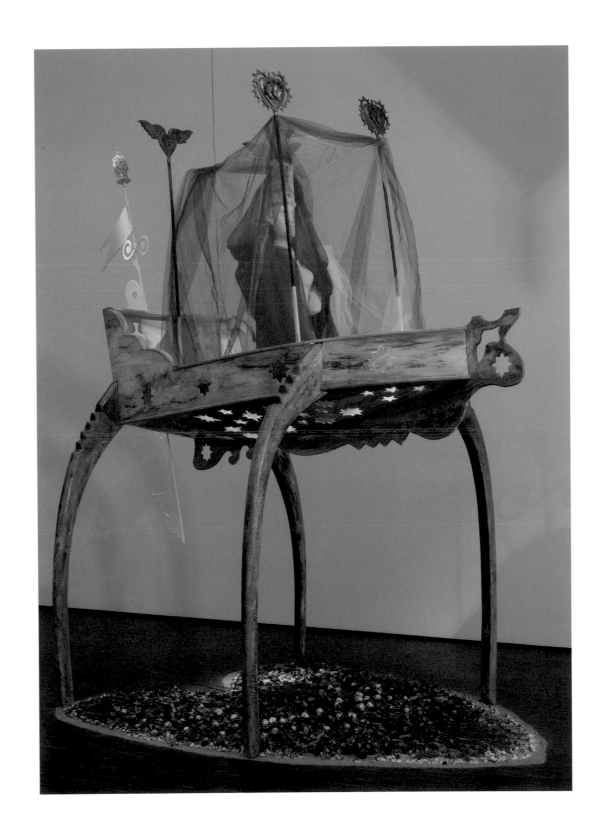

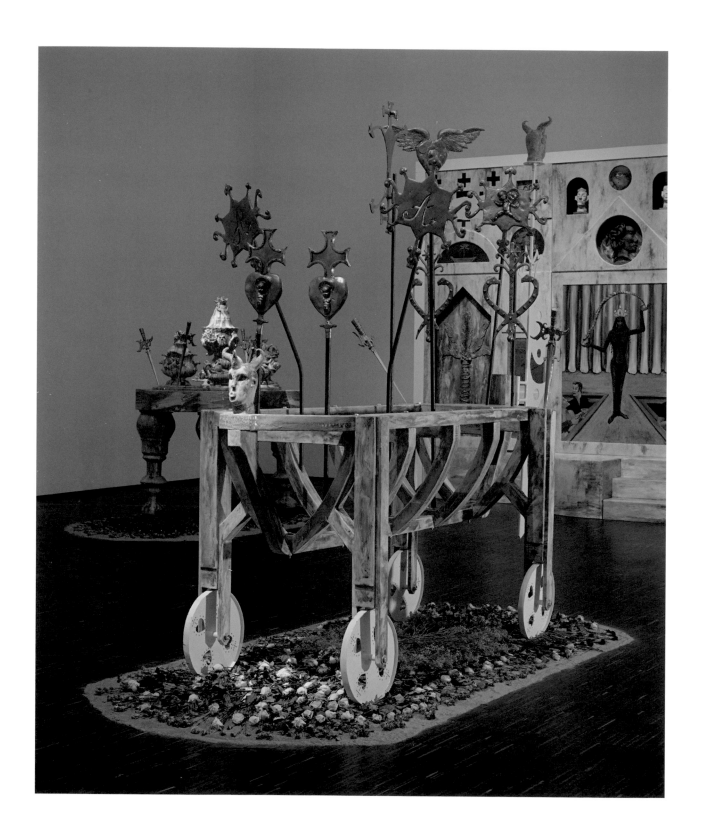

vodou *lwas* and the ways they are depicted in Edouard's art.[5] This book was later the subject of a special section of *Small Axe*, the journal of Caribbean arts and culture in October 2008, dedicated to Duval-Carrié's work.[6]

My journey to Port-au-Prince with Edouard in the fall, 2007, was especially memorable. Arriving on November 1 and spending November 2 and subsequent days in and around the capital, this trip constituted one distinctly poignant experience after another. November 1 (La Toussaint) and 2 (Jour des Morts) are, of course, sacred days in both the Christian and the vodou religions. These are the Days of the Dead: the feast of All Saints and All Souls. Vodouists gather at cemeteries and celebrate their deceased *confrères* and family members, conjuring up their spirits with the sound of drums. Drumming pervaded my nights in Haiti and the days were filled with visits to artists (including the metal workers in their studios in the town of Croix-des-Bouquets) and Edouard's paternal home. It was at that point that I first came into contact with the work of the young artists who would become known as the "Atis Rezistans" or the "Artistes de la Grande Rue" for their resistance to corruption and societal degradation and their mordant political commentary. Their often-massive sculptures were created in makeshift studios in and near the teeming principal street (La Grande Rue) of downtown Port-au-Prince. Several years later, in 2012, these artists participated, along with Duval-Carrié, in a remarkable exhibition, curated by Donald J. Cosentino for the Fowler Museum at UCLA. *In Extremis: Death and Life in 21ˢᵗ Century Haitian Art* charted in a series of extraordinary two- and three-dimensional works, the quintessential role that death and coping with its imminent presence, has played in the Haitian imaginary for decades.[7]

One of the major points of stimulus for the creation of Cosentino's exhibition, as well for the subject matter of many of Edouard's works was the terrible earthquake that occurred in the late afternoon of January 12, 2010, in which more than 200,000 people perished and over 300,000 were injured and left homeless. Although I was not in Haiti on that frightful evening, I was in Miami, visiting Edouard, his wife Nina Duval and a close friend and associate, Mireille Chancy Gonzalez, a long-time supporter and promoter of Haitian art in the Miami area. My visit coincided with this terrifying experience, made all the more vivid by being not only with Edouard and his

5 Edward J. Sullivan (ed.), *Continental Shifts: The Art of Edouard Duval-Carrié* (Miami: American Art Corporation, 2007).

6 See the following essays: Jerry Philogene, "The Continental Conversations of Edouard Duval-Carrié," LeGrace Benson, "On Reading *Continental Shifts* and Considering the Works of Edouard Duval-Carrié," and Edward J. Sullivan, "Navigating Between the Continents: Further Thoughts on Edouard Duval-Carrié's Work," in *Small Axe: A Caribbean Journal of Criticism*, number 27, October, 2008, pp. 143-150, 151-164 and 165-174, respectively.

7 Donald J. Cosentino (ed.), *In Extremis: Death and Life in 21ˢᵗ Century Haitian Art* with essays by Cosentino, Edwidge Danticat, Leah Gordon, Katherine Smith and others (Los Angeles: Fowler Museum of Cultural History, UCLA, 2012).

◀[facing page and above] Edouard Duval-Carrié, *La Destruction des Indes*, 1992, installation views from 2005, Figge Art Museum, Davenport, Iowa.

friends and family but also with dozens of other Haitians in a restaurant in Little Haiti. All of its patrons were frantically attempting to contact their own families in Port-au-Prince and beyond. It was truly a moving, saddening and sobering experience.

ED-C: Artist, Art Historian and Curator

Throughout his career Edouard Duval-Carrié has utilized historical events— in both a political and a spiritual sense—as points of reference for his work. On August 16, 2014, I was invited to Miami to participate in a panel held at the Pérez Art Museum Miami (PAMM) to celebrate the exhibition and catalogue *From the Revolution to the Tropics: The Art of Edouard Duval-Carrié*.[8] The exhibition was a testimony to the erudition of the artist. Virtually all of the pieces in the show (as well as in the very useful catalogue edited by Caribbean scholar B. Anthony Bogues, with whom Edouard has worked on projects at the Center for the Study of Slavery and Justice at Brown University)—from smaller paintings to large installations, made singularly pointed references to historical themes. These included the Haitian Revolution (a subject long developed by Edouard, who is especially fond of investigating the imagery related to the major protagonists of the war, from Toussaint L'Ouverture to Jean-Jacques Dessalines), the conquest of Hispaniola by the Spaniards, and, in a nod in the direction of the history of Surrealism, a depiction of the encounter at the newly opened Centre d'Art of André Breton with Hector Hyppolite when the "Pope of Surrealism" came to Haiti in 1945. Breton subsequently purchased works by the artist and wrote glowingly about his "exotic" work in his famous anthology *Le Surréalisme et la Peinture* (Surrealism and Painting).[9]

The exhibition itself was dedicated to what Edouard called his "imaginary landscapes." These comprised large canvases based on compositions of the principal members of what is often called the Hudson River School of nineteenth century North American landscapists. Duval-Carrié appropriated compositions by Martin Johnson Heade, Albert Bierstadt and Frederic Edwin Church, populating them with figures derived from the vodou pantheon as well as those from contemporary popular culture. One of the most intriguing images was *After Bierstadt—The Landing of Columbus* showing Christopher Columbus in a boat with such companions as Mickey and Minnie Mouse, Batman and Donald Duck. This is the characteristic blending of intense familiarity with the history of art and Edouard's willingness to transform it into a (sometimes irreverent) commentary the on current affairs of society.

Duval-Carrié's constant concern with social and art history as well as the cultural patrimony of Haiti enters squarely within his curatorial projects. I briefly commented above on his *Global Caribbean* shows that have, as their

8 Anthony Bogues (ed.), *From the Revolution to the Tropics: The Art of Edouard Duval-Carrié* (Miami: Perez Art Museum Miami, 2014), with essays by Anthony Bogues, Carlo A. Célius and Tobias Ostrander.

9 André Breton, *Le Surréalisme et la Peinture* (Paris: Gallimard, 1965), pp. 308-312.

desired result, the propagation of knowledge of the works of contemporary artists from throughout the region. Among his most outstanding projects as curator (with the assistance of Maggie Steber) was the organization of the exhibition *From Within and Without. The History of Haitian Photography* presented during the summer and fall of 2015 at the NSU Art Museum / Fort Lauderdale. Haitian photography forms a rich but very little studied chapter within the development of art from the later nineteenth century to today. The exhibition presented a generous panorama of work drawn primarily from private collections charting Haiti's history and its adaptations of the early experiments in the photographic processes first developed in England and France in the 1830s. I had the opportunity to contribute to this effort with an essay regarding the representation of Haitian artists by photographers from the 1940s through the 1970s.[10]

This exhibition represented the perfect amalgam of the talents and concerns of the artist (who designed a highly evocative installation for the show). It coalesced Edouard's own engagement with visuality in its widest possible manifestations and presented to the public, at the same time, a broad spectrum of the manifold talents of dozens of photographers, both Haitian and foreign, for a general public. The exhibition was, therefore, an intriguing manifestation of a *Gesamtkunstwerk*—a "total work of art."

The present exhibition takes up virtually all of the above-discussed themes: Duval-Carrié's social concerns, his spirit of collaboration with other artists and students, his dedication to the need for art instruction and pedagogy as well as serving as a platform for studying his ongoing and constantly-developing and constantly-refined achievements in a wide variety of media and techniques.

—*Edward J. Sullivan*

▲[top] Albert Bierstadt, *The Landing of Columbus, ca.*, 1893, oil on canvas, 80 x 120 inches. This version (one of an original three paintings by Bierstadt) is in the Collection of the City of Plainfield, New Jersey. Public domain.

▲[bottom] Edouard Duval-Carrié, *After Bierstadt—The Landing of Columbus*, 2013, mixed media on aluminum, 96 x 144 inches.

10 Edward J. Sullivan, "Artists Before the Lens. Painters and Photography in Haiti," in Edouard Duval-Carrié and Maggie Steber, *From Within and Without. The History of Haitian Photography* (Fort Lauderdale, NSU Art Museum, 2015), pp. 28-33.

It's All Happening in the Margins:
An Interview with Edouard Duval-Carrié

Lesley A. Wolff

▲Installation view, *Cabinete de Curios-ités* [objects from Edouard Duval-Car-rié's personal collection], 2017. Image courtesy of the Museum of Contempo-rary Art, North Miami.

[On September 1, 2017, as Hurricane Irma was bearing down on the Caribbean, and while Edouard Duval-Carrié was completing installation on an exhibition at the Museum of Contemporary Art, North Miami, he and Lesley A. Wolff met to discuss a number of thematic interests and important philosophical contexts revealed in his latest works.]

LW: Your recent work, which will be exhibited this Spring at the Museum of Fine Arts in the exhibition *Decolonizing Refinement: Contemporary Pursuits in the Art of Edouard Duval-Carrié*, demonstrates new artistic considerations but it also maintains continuity with your past interests. One of the most elaborate series of works in the show is your interpretation of *The Kingdom of This World* (1949), Alejo Carpentier's magical realist novel about the Haitian Revolution. You mention that this novel has been greatly influential to you throughout your artistic career, but it is only now that you've directly engaged the novel visually.

ED-C: I first encountered Carpentier's book when I was 12 or 13—at that time I lived in Puerto Rico. I read it and it was really . . . to me it was a first contact with Haiti. I mean, I'm from Haiti, but to get the history from that angle, somebody looking at it from such a different way. I know my Haitian history, but

it was never told in that fantastic fashion, in that totally crazy way. And I loved it. As I become more knowledgeable, I find that it was the beginning of magical realism, and I realized that it's true, that *that* is Haiti, do you understand? It is fantastic realism, magical realism, because everything about the reality of Haiti is so incredible and so particular. And I've always thought it was the best book written on Haiti. I've always used those characters in my repertoire of characters . . . Makandal [for instance] one of my first paintings was about Makandal.

In Haitian history, they really start with the Revolution. They never talk to you about what happened before. So, it was like not a revelation—because I knew about it—but it *was* a revelation, to realize how the colonial period was as important to the formation of that nation as what happened post-Revolution. The whole idea of Haiti was already there, long before the Revolution. For me, I was quite surprised to realize that everything about us is from that colonial period—the social constructs, the way we think of ourselves, the French language. And now with this whole idea of "refinement," we [Haitians] are the bases of that as well.

LW: What prompted you to revisit this novel now?

ED-C: First of all, I've been a diligent student of Haiti and I found myself really put to the exigencies of showing to myself and others how *basic* this whole colonial revolution has been. It had consequences on a much larger level than just what happened on the island. I mean I could do a whole project on repercussions of the French and Francophone world, even in places like Florida. I'm finding out that the whole concept of the plantation system has been integrated so much here [in Florida] and it's not different from anywhere else in the New World. They don't have plantations like that in Europe [that are] rooted in this whole idea of having forced labor or labor implanted on the production side. I think it's a New World construct. Even in India, the colonizers of India and China could not have that kind of organization, of occupying a land, and then bringing all of this forced labor. You require other social constructs. So, to me the United States thinks of itself as very foreign to these kinds of problematics, but it is at the core of the history of this nation, of how they [Americans] think of themselves. One of the worst civil wars in the history of mankind was the US Civil War—and that was all about whether we should eliminate the plantation system or not.

LW: You raise this idea of "the core" of the nation as a notion rooted in "the problematics" of production and labor, which has me thinking about how you incorporate historical images into your work. Lately your work has become more focused on types of historical and botanical illustrations.

ED-C: This compendium of commodities, you know? They [illustrations] were created to find any thing that could serve for industry—for me it's very important to look at all of that. And I think they're beautiful, visually. I think they're fascinating.

LW: Thinking about layers: layers of history, layers of institutions, layers that literally comprise your work. In this regard, I find *The Kingdom of This World* particularly interesting. The mode of production you employ is very layered.

ED-C: That's true.

LW: Your illustrations for *The Kingdom of This World* comprise multiple media. You have etched acrylic plates with illustrations of Carpentier's descriptive imagery. From these plates you have produced prints. Using FSU's Facility for Arts Research, you have duplicated these acrylic plates and framed them as museum objects in their own right. In addition, you have produced paintings based on this imagery. Can you tell us why you've chosen to convey these scenes in multiple ways? Is there a conceptual motivation? This seems to resonate with ideas of "refinement."

ED-C: Now that you mention it, I had decided to make sure that the work I did had a sequence. I realize that when I go directly to a large canvas or a large work I always have to revisit it. It never congeals well at first. And my work *is* so layered. And so complex. I decided to go back to make sure I produce studies first and that on whatever surface I use, that the idea was well developed before attacking what it was I saw in my head. Sometimes I should have stayed with the study, you know?! [He laughs.]

LW: You let us in to that study, to that process, and that heightens our ability to read the rest of your work.

ED-C: Exactly.

LW: There's an interesting dynamic between your artistic practice and the historical critiques you embed in your work, which are both very much about processes of refinement. In fact, the impetus for our collaboration came from *Sugar Conventions*, which is a critique and examination of plantation culture onto which you've cleverly affixed *actual sugar* mixed with a glittering paste. Can you elaborate on the relationship between the inclusion of the product itself and a critique of its process?

▲[top] Edouard Duval-Carrié, *Ti Noël in Sans Souci*, from *The Kingdom of This World* series, 2017, engraving on Plexiglas, 31 x 27 inches.

▲[bottom] Edouard Duval-Carrié, *Metamorphose #1*, from *The Kingdom of This World* series, 2017, engraving on Plexiglas, 31 x 27 inches.

▶[facing page] Edouard Duval-Carrié, *L'Orange De Mme Lenormand De Mezy*, from *The Kingdom of This World* series, 2017, engraving on Plexiglas, 31 x 27 inches.

ED-C: First of all, I read about refinement in *Slavery, Sugar, and the Culture of Refinement* by Kay Dian Kriz (2008), and I was so enthralled with that book. I had never been confronted with the relationship between the production [of sugar] and art . . . I had never considered how one product could prompt a whole aesthetic. That was fascinating to realize, and also that it was so close to me. I mean, we call the Caribbean the "Sugar Islands," all of us, you understand? So it's really a Caribbean story, what Kriz was trying to tell us. To realize how we organized and reconfigured a movement of aesthetics in places like France relative to one commodity. Their cultural Golden Age is related to this period of a massive influx of that particular commodity, sugar, and the wealth it brought. It opened up all sorts of avenues for me, in terms of

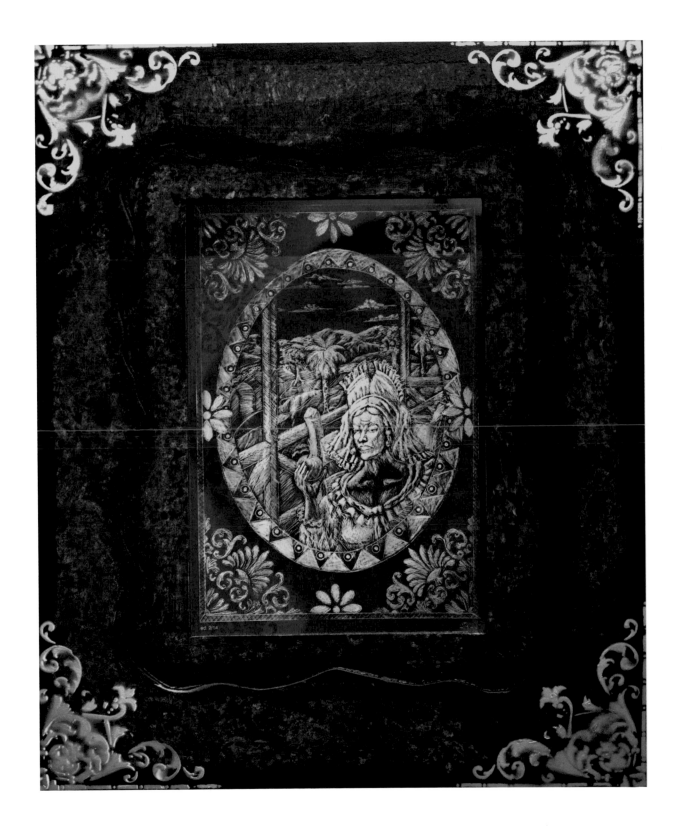

▲Edouard Duval-Carrié, *Memory Windows*, 2017, installation view from the Museum of Contemporary Art, North Miami, 58 x 58 inches each.

looking at the whole colonial period and how it was organized in a place like Haiti and realizing that it belongs to the formats seen everywhere else in the New World. Places like the United States, that think that they're very modern societies, are also issued from that [structure], you know? I'm very interested in history, not only history, but the history of art as well, but I never lose sight of the fact that I'm a contemporary artist, living in a contemporary world, with things happening at such a fast pace. I have to figure out where I draw the line or how relevant are these things . . .

LW: Is your hope that people view your work and become curious about the past in the way that you became curious about the past?

ED-C: And to understand where they stem from. People have the most incredible capacity to forget. And [they] don't realize the historical processes that led them to where they are today. If they understand one part of it they might *really* understand the kind of positions they're in.

LW: I think the literal inscription of historical images in your work emphasizes that point.

ED-C: Yes, because I'm not *inventing* anything. And I don't feel any qualms about using any documents. Those are documents that have made an impact, which are suddenly being relegated to the bookshelves of libraries and institutions. But these documents probably were debated and very much in the forefront of the minds of people in the times in which they were created. And they were done with a purpose. That's what people forget: that this purpose maybe has not been erased.

LW: Something that I find interesting about your artistic approach is the way in which you use the Francophone to incorporate an attitude—I know you've used this term in the past—of "politeness." There's an ease to the relationship between subject and object in your work. Going back to *The Kingdom of This World,* Carpentier's novel contains many passages that recount amputations, mutilations, and metamorphoses of the book's main characters. Many of these are deeply violent and visceral moments in the text. Can you talk about why you've chosen to illustrate these bloody and intense corporeal transformations with ornate flourishes, foliated forms, picturesque landscapes, and an overall sense of Western "elegance"?

ED-C: I try to recapture that whole era Carpentier is talking about by using what I call "conventions," like stenciled borders, to accentuate the image but also to distance yourself from the image. If you cannot digest the image then look at the borders and you might like it. It's a ploy to get you to engage the image. And it also brings you back to the sense of refinement of that period, of the French tendency to overly decorate. There is a quality to French aesthetics that's very peculiar and that you only find there. And you can extend it to the rest of Europe, but they [the French] have the means to really go at it and to go at it

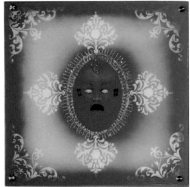
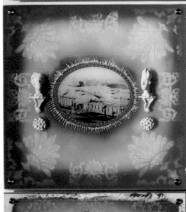
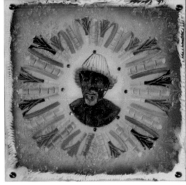

▲Edouard Duval-Carrié, detail of *Sugar Conventions,* 2013, mixed media on backlit Plexiglas, 72 x 72 inches. Courtesy of the Winthrop-King Institute for Contemporary French and Francophone Studies, Florida State University, Tallahassee, Florida.

bigger [than other nations]. For the French, it was pervasive, because there was much more wealth in that particular nation, due to one particular product—sugar—that permitted it to have a kind of national aesthetic.

LW: Currently, you have an exhibition of your work at the Museum of Contemporary Art, North Miami, which is entitled *Metamorphosis*.

ED-C: It's really looking at my work and to see how it's gone through such changes. And to see the way one can take an image and change it over and over and every time you might have new meanings or it might have other resonances. Or it might have other ways of dictating what you're looking at.

LW: There is a lot of conversation between this exhibition and our collaboration at the Museum of Fine Arts. At Florida State, we're trying to emphasize a decolonial approach. Do you see "metamorphosis" as a framework to work through decolonizing processes?

ED-C: In the sense that I work on histories that have not been digested yet, yes. I am looking at it on so many different formats and different periods, looking at it geographically and from different perspectives. I thought it was maybe futile because it's a history that's known, but I realize that there's a much more complex mechanism behind it. You see the frustration today of not understanding how things have happened—and this is everywhere.

LW: I sometimes read that sense of frustration in the fabrication of your work, particularly in the dialogue between the layers you've composed. There's a tension, in *Sugar Conventions*, for instance, between the glittered numbers you've superimposed over the sweetness of an image originally painted by Agostino Brunias. There are ideas of caste, hierarchy, and human agency layered there.

ED-C: I'm critiquing the kind of propaganda used for the Caribbean.

LW: Using those docile images to bring that tension back into the image is a decolonial approach.

ED-C: Yes. You find out why the images were produced, originally, and you realize that they were coded back then, and you really have to understand the coding of these images to really get the complexity of the situations that were being described. This character Brunias, for example. He was creating a new world for the Caribbean. Like [Theodor] de Bry. It was real to a certain point, but he left out a lot. *A lot . . . A lot.*

LW: I want to return to something you've mentioned at the beginning of our conversation, the Tallahassee region and its plantation heritage. From an artistic vantage point, how does your encounter with the Tallahassee landscape and its cultural heritage speak to you and to your body of work?

ED-C: There's a colonial flare to the region. First of all, it's the seat of the state. I'm very curious to see what the relationship is to the rest of the United States but also regionally and internationally. Where was it back in the periods of turmoil of their neighbors, where was Tallahassee situated politically? I want to try to understand the modus operandi of a region like that. There are so many stories. I'm very curious to find out if the cycles of the Haitian Revolution had any impact on that particular region, which surely they did from what I've seen. Immediately, when I saw the region, Haiti comes back to mind. And the Marquis de Lafayette[1] was certainly an important voice in postrevolutionary America. I want to know exactly what his affiliations were in the region. As a nobleman from France, he was very comfortable with the production of commodities like sugar. I would like to know about his understanding of the wealth of nations. What did that [wealth] mean to him? He was an important political thinker for his time and I want to know what his positions were.

LW: To return to the 'Marvelous Real,' which you mention at the beginning, do you think there is a way to put that in conversation with the heritage of Tallahassee?

ED-C: If what I think is true, or if what I am concocting in my head is true, it is Marvelous Realism, because it's a very hidden thing. And suddenly you have a cast of characters and ideas floating throughout the Caribbean. It's not from a metropolis to a colony; it's between all the colonial systems. It's a new way of looking . . . it's all happening in the margins.

—*Lesley A. Wolff*

1 In 1825, the US government gifted French aristocrat, the Marquis de Lafayette (1757 – 1834), a land grant of over 23,000 acres in Leon County, Florida, as a gesture of gratitude for his financial support during the American Revolution. Though many of Lafayette's French acquaintances subsequently settled in the area, it is unclear whether Lafayette himself ever spent time in north Florida.

▲*Cabinete de Curiosités*, 2017, installation photo from *Metamorphosis*, Museum of Contemporary Art, North Miami. Image courtesy of the artist.

Edouard Duval-Carrié, detail of *The Great Florida Marsh—After Martin Johnson Heade*, 2014, mixed media on acrylic, 12 x 8 feet. Image courtesy of the artist.

HISTORICAL AND
CONTEMPORARY ARTIFACTS

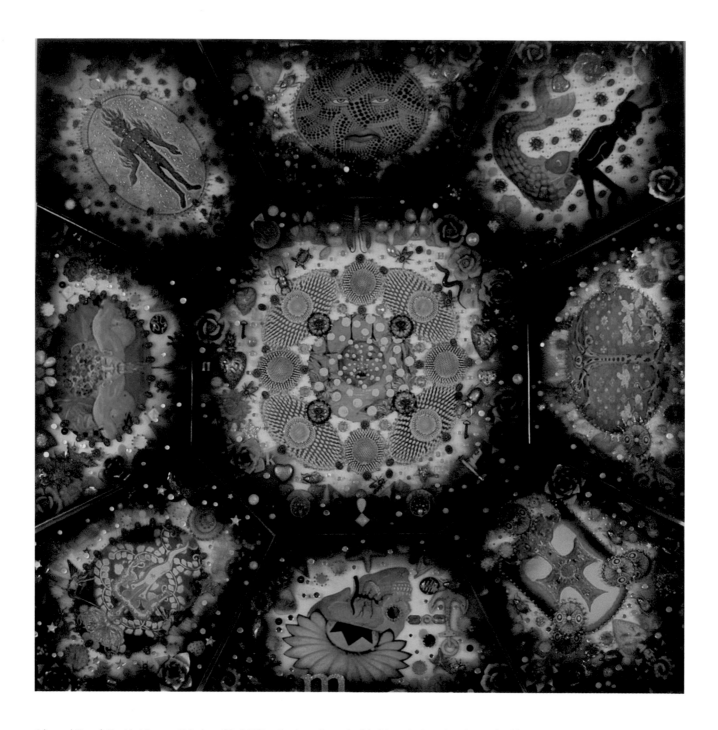

Edouard Duval-Carrié, *Memory Window #3*, 2017, mixed media embedded in resin in artist's frame, backlit, 58 x 58 inches. Image courtesy of the artist.

Edouard Duval-Carrié, *Memory Window #5*, 2017, mixed media embedded in resin in artist's frame, backlit, 58 x 58 inches. Image courtesy of the artist.

Edouard Duval-Carrié, *Memory Window #7*, 2017, mixed media embedded in resin in artist's frame, backlit, 58 x 58 inches. Image courtesy of the artist.

Edouard Duval-Carrié, *Memory Window #8*, 2017, mixed media embedded in resin in artist's frame, backlit, 58 x 58 inches. Image courtesy of the artist.

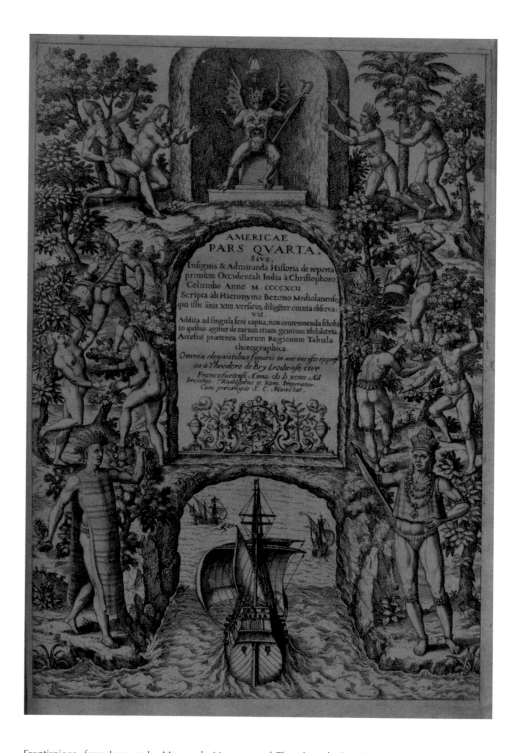

Frontispiece, from Jacques Le Moyne de Morgues and Theodore de Bry, *Brevis narratio eorvm qvae in Florida Americae provicia Gallis acciderunt*, 1591, Rare Books Collection, Special Collections and Archives, Florida State University, Tallahassee, Florida.

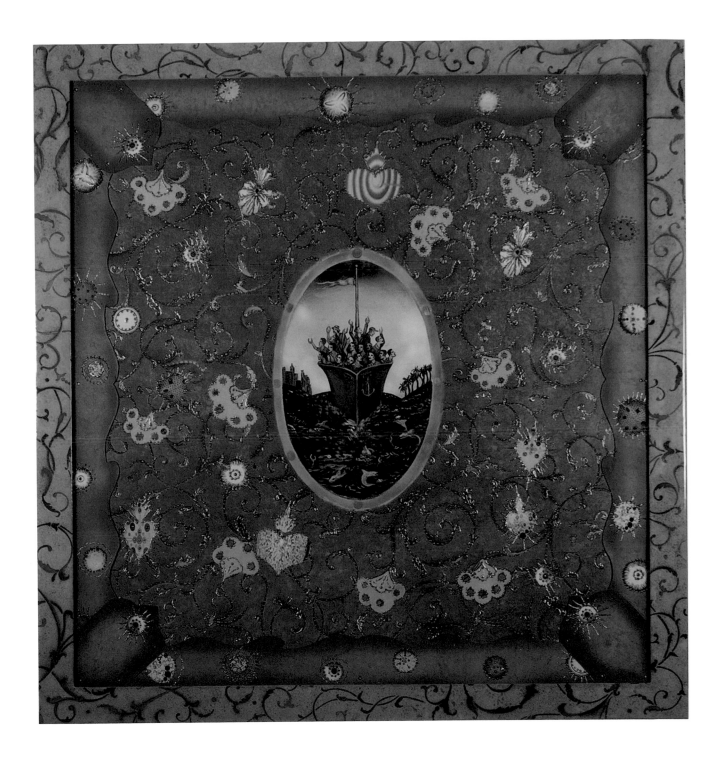

Edouard Duval-Carrié, *Detresse*, 2015, 55¾ x 53 inches. Lyle O. Reitzel Gallery New York—Santo Domingo.

Edouard Duval-Carrié, installation view, *Metamorphosis*, 2017, Museum of Contemporary Art, North Miami. Image courtesy of the artist.

Edouard Duval-Carrié, *Capitaine Tonnerre*, 2017, mixed media, 60 x 48 inches. Image courtesy of the artist.

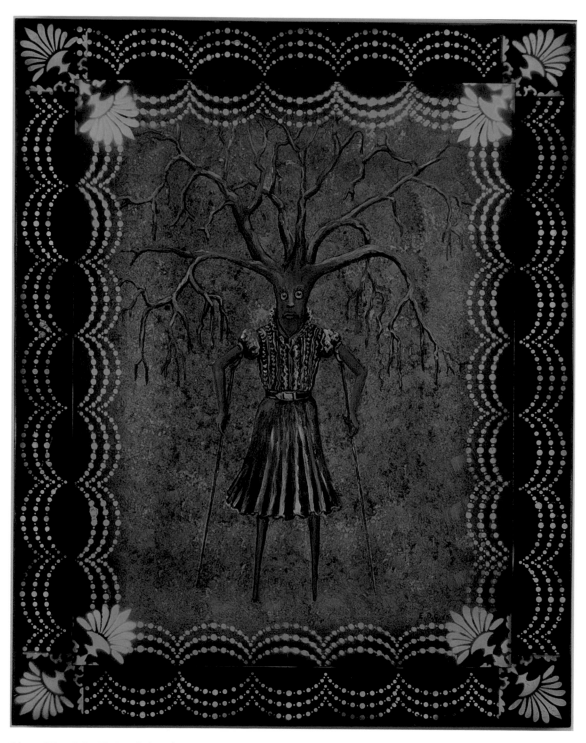

Edouard Duval-Carrié, *Crippled Mother*, 2015, mixed media on paper in artist's frame, 36 x 36¼ inches. Lyle O. Reitzel Gallery New York—Santo Domingo.

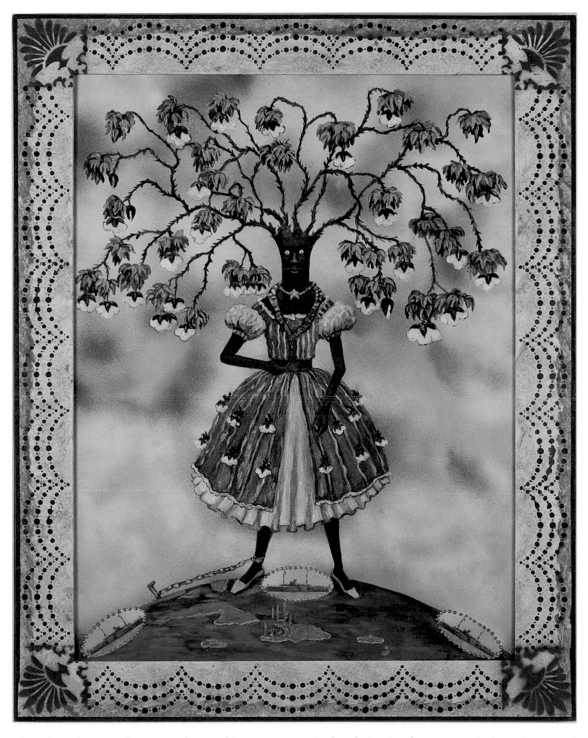

Edouard Duval-Carrié, *Of Cotton, Gunboats and Petticoats*, 2015, mixed media in artist's frame, 36 x 28 inches. Lyle O. Reitzel Gallery New York—Santo Domingo.

Erasmus Francisci, detail of cotton, *Ost- und west-indischer wie auch sinesischer lust- und stats-garten*, 1668, Rare Books Collection, Special Collections and Archives, Florida State University, Tallahassee, Florida.

Cotton motif, ceiling fresco detail, Goodwood Museum and Gardens, Tallahassee, Florida. Photo credit: Owen Enzor.

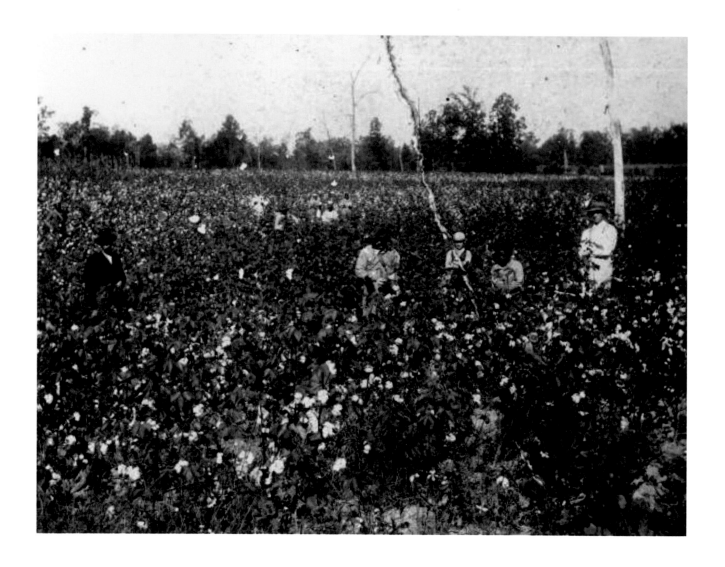

Field of cotton, Gadsden County, Florida, ca. 1910, black and white photo print, 8 x 10 inches. State Archives of Florida, Florida Memory.

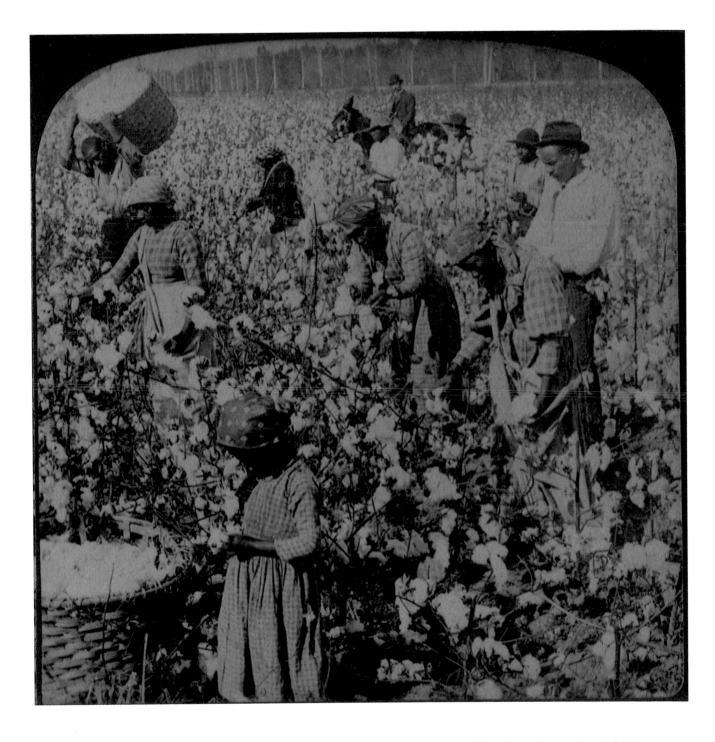

African-American workers harvesting cotton, Thomas County, Georgia, *ca.* 1880. Image courtesy of the Thomas County Historical Society.

Bureau of Archaeological Research
Nos. 78.101.268.118, 78.101.457.17, and
08.209.124.5

in

cm

Lightning whelk celt with drilled holes and fine preserved working edge, shell, date unknown, 7¾ x 4½ x 4½ inches. Image courtesy of the Florida Division of Historical Resources.

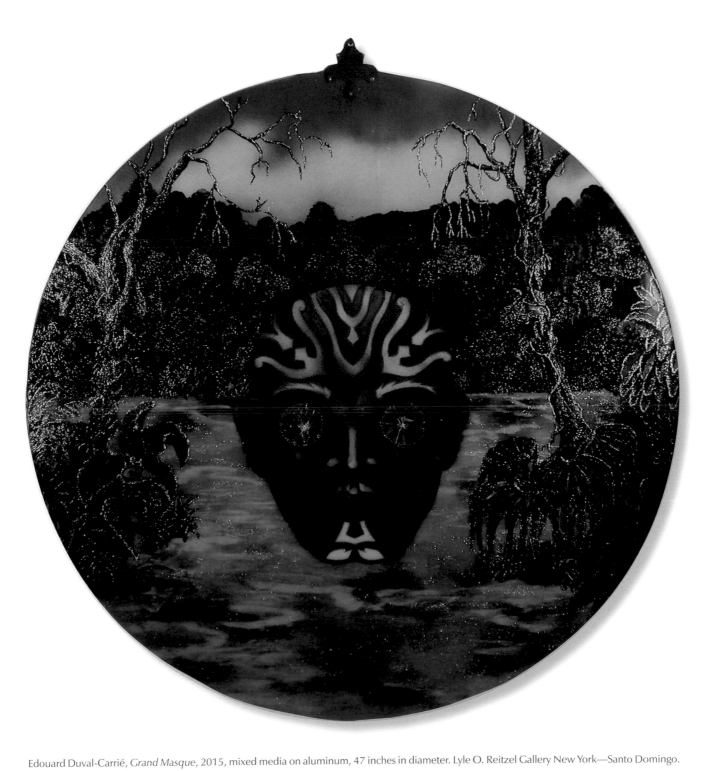

Edouard Duval-Carrié, *Grand Masque*, 2015, mixed media on aluminum, 47 inches in diameter. Lyle O. Reitzel Gallery New York—Santo Domingo.

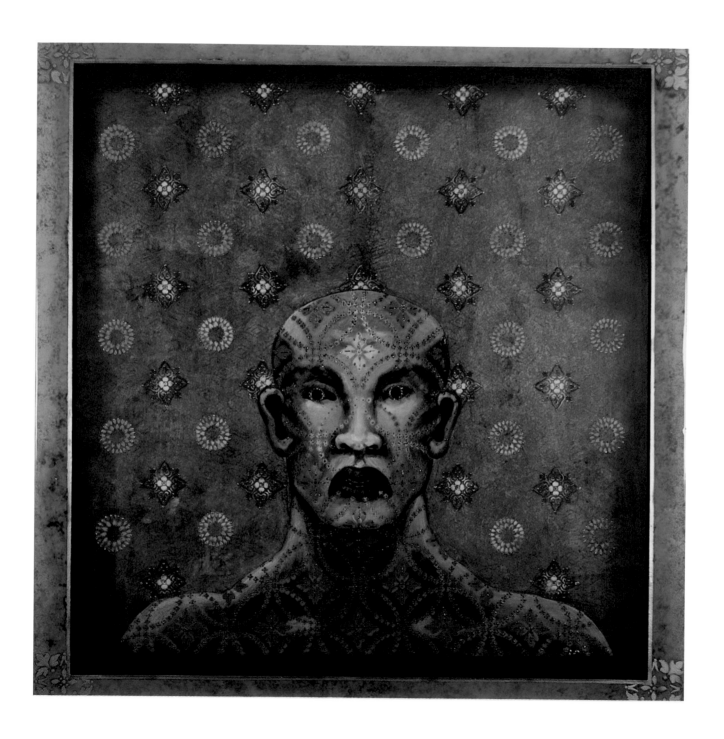

Edouard Duval-Carrié, *Man in Blue*, 2015, mixed media in artist's frame, 55 x 55 inches. Lyle O. Reitzel Gallery New York—Santo Domingo.

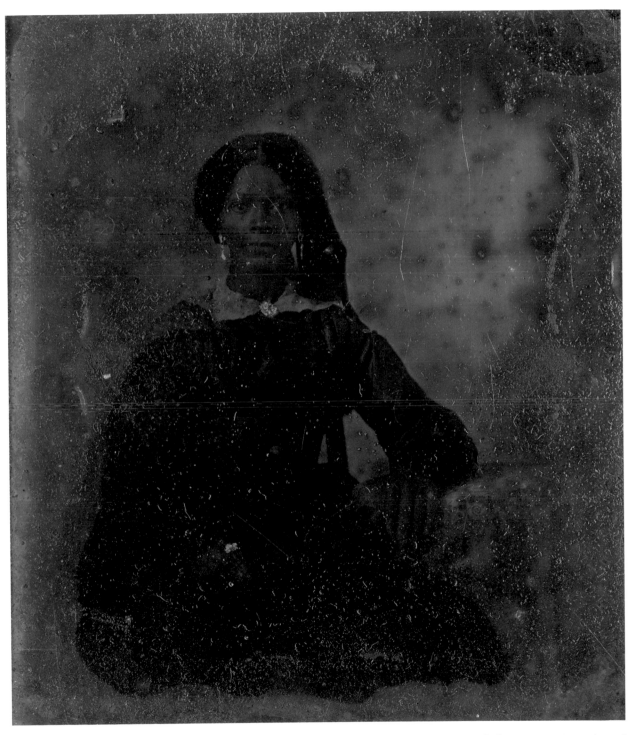

Portrait of a woman named 'Sarah,' enslaved or formerly enslaved by the Jones family of Greenwood Plantation, *ca.* 1858, framed daguerrotype, 3¾ x 3¼ inches. Courtesy of the Thomas County Historical Society.

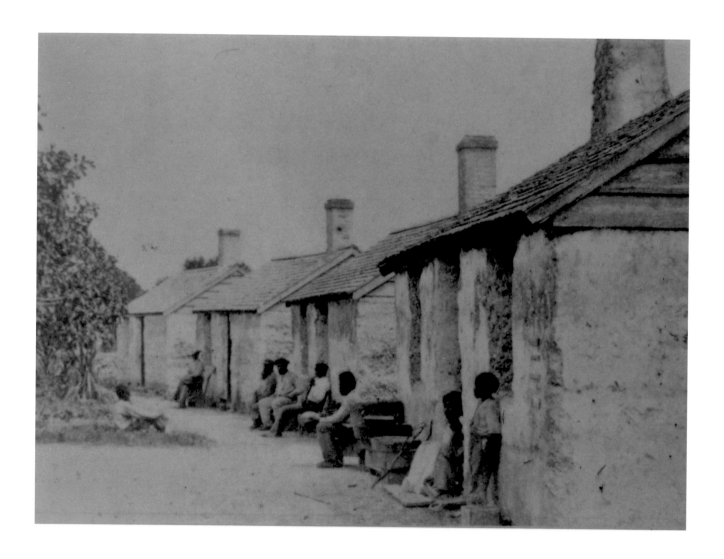

Quarters for former slaves, made of tabby concrete, at the Kingsley Plantation on Fort George Island in Jacksonville, Florida, ca. 1880-1899, sepia stereograph, 3½ x 7 inches. State Archives of Florida, Florida Memory.

Richard Parks, view showing former slave quarters of "The Columns" in Tallahassee, Florida, 1967, color photonegative, 5 x 4 inches. State Archives of Florida, Florida Memory.

Edouard Duval-Carrié, *Swamp Beasts*, 2007, oil on canvas in artist's frame, 66 x 74 inches. Lyle O. Reitzel Gallery New York—Santo Domingo.

Edouard Duval-Carrié, *Underground Rites*, 2016, mixed media on panel in artist's frame, 35½ x 28 inches. Lyle O. Reitzel Gallery New York—Santo Domingo.

POINT ISABEL.

"A picture of perfect loveliness." — *Scribner's Monthly*.
"One of the loveliest and most striking prospects of Fort George Island. The woody point terminates in three sentinel palms, and at one's feet are the yellow sands and the surf perpetually rolling on the bar, whose rhythmic roar is faintly wafted upon the air, fragrant with the odor of many flowers."
—*Harper's Monthly*.

Interior page, pamphlet advertising Fort George Island, Duval County, Florida, ca. 1888, published by the Fort George Island Company. Image courtesy of State Library of Florida, Florida Collection.

Edouard Duval-Carrié, *Future Landing*, 2003, mixed media in artist's frame, 65 x 50 inches. Lyle O. Reitzel Gallery New York—Santo Domingo.

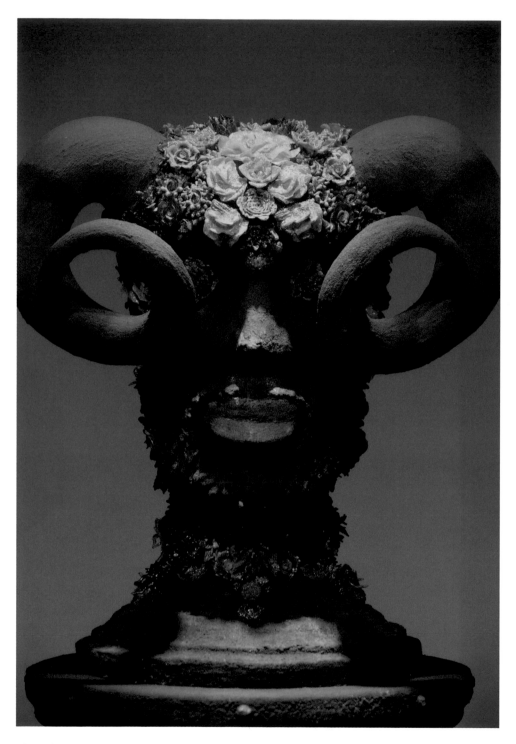

Edouard Duval-Carrié, *Bossou*, 2016, mixed media, 45 x 41 x 29 inches. Image courtesy of the Museum of Contemporary Art, North Miami.

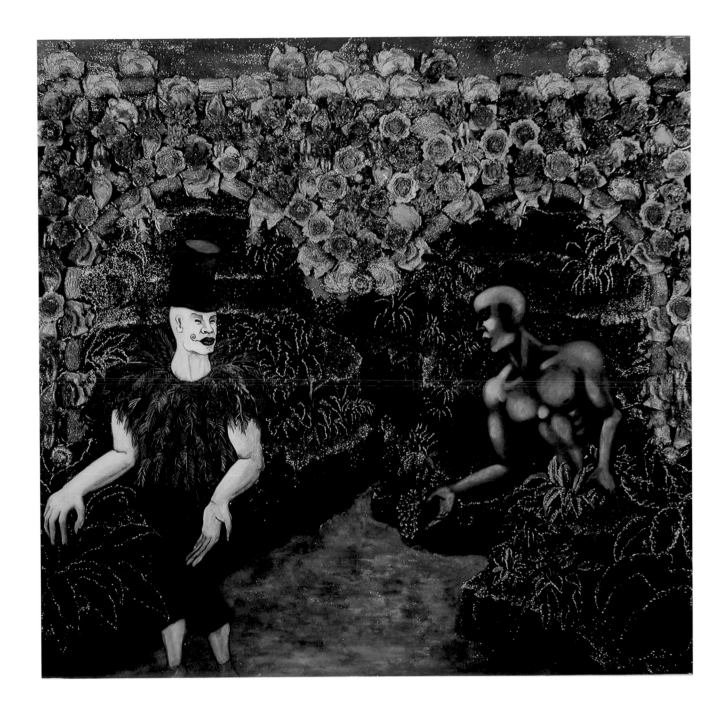

Edouard Duval-Carrié, *El extraño de los zombies* (*The Foreign World of the Zombies*) from the *Triptych des Mysteres*, 2016, mixed media on aluminum, 60 x 60 inches. Lyle O. Reitzel Gallery, New York—San Domingo.

Edouard Duval-Carrié, left panel from *Triptych des Mysteres*, 2016, 60 inches square, and thumbnail of triptych.

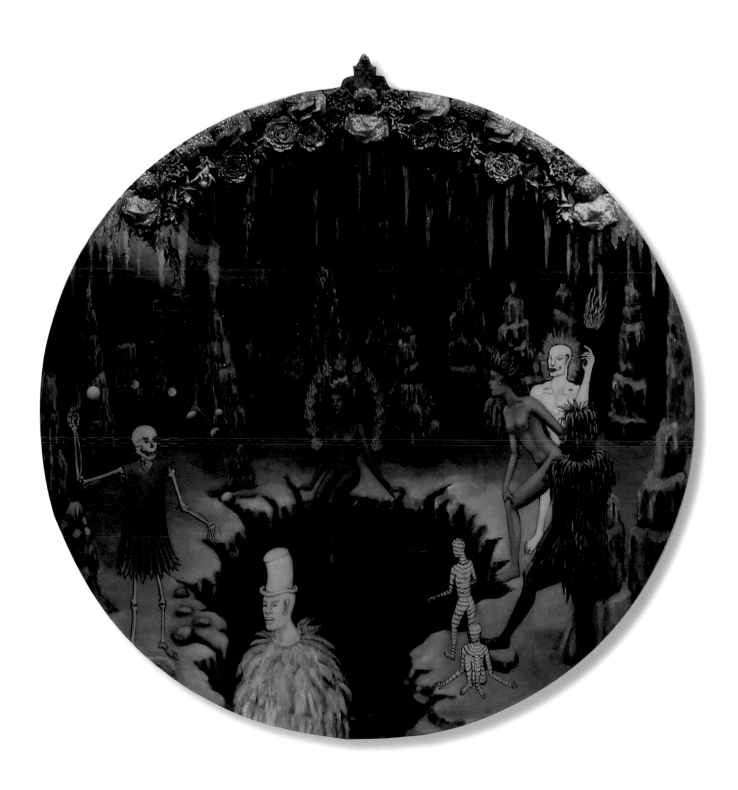

Edouard Duval-Carrié, center tondo from *Triptych des Mysteres*, 2016, 40 inches in diameter.

Edouard Duval-Carrié, *Mountain Creeper*, 2015, mixed media on aluminum, 47 inches in diameter. Lyle O. Reitzel Gallery New York—Santo Domingo.

Erasmus Francisci, detail of botanical illustrations, *Ost- und west-indischer wie auch sinesischer lust- und stats-garten*, 1668, Rare Books Collection, Special Collections and Archives, Florida State University, Tallahassee, Florida.

Edouard Duval-Carrié, *L'Homme Brodé*, 2015, mixed media on paper in artist's frame, 28¼ x 35½ inches. Lyle O. Reitzel Gallery New York—Santo Domingo.

Edouard Duval-Carrié, *Soucouyant #1*, 2017, mixed media, 95 inches in diameter. Image courtesy of the artist.

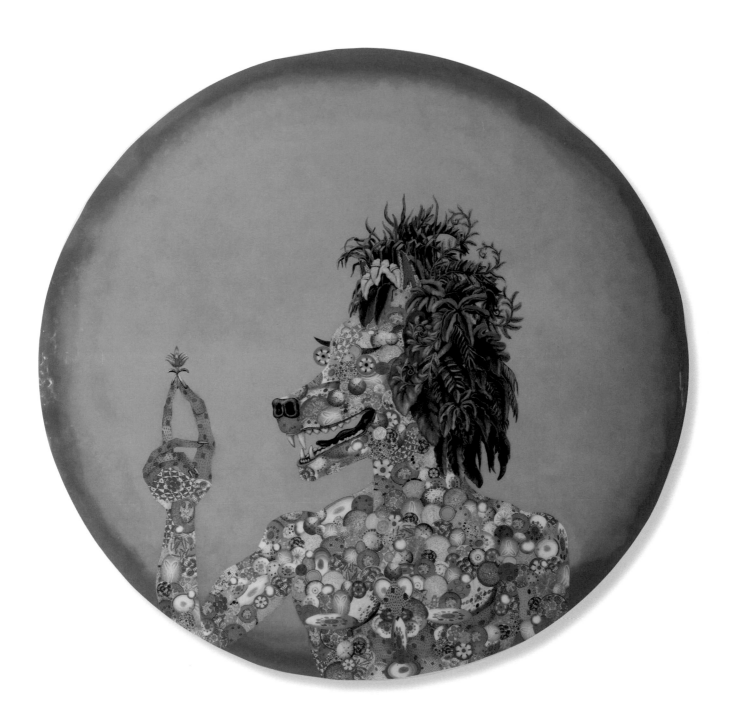

Edouard Duval-Carrié, *Soucouyant #2*, 2017, mixed media, 95 inches in diameter. Image courtesy of the artist.

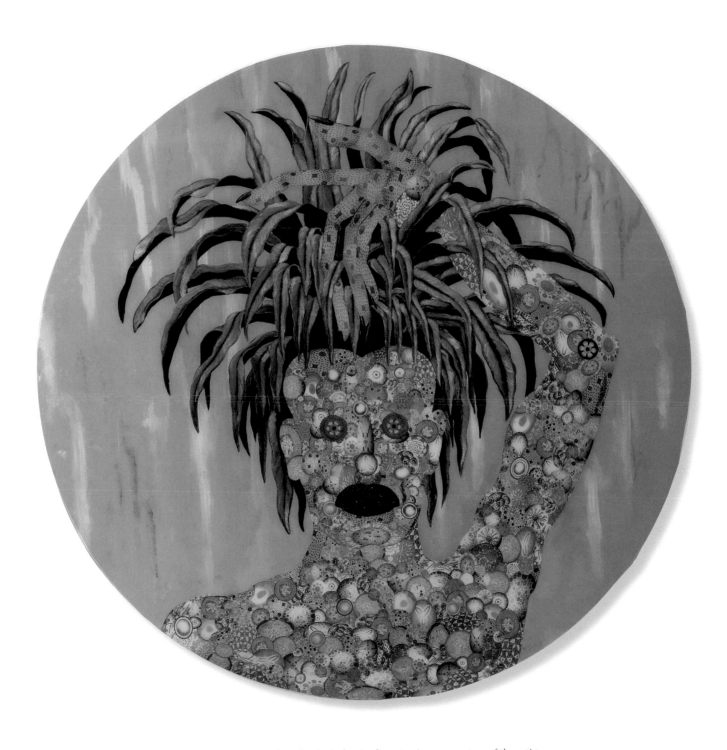

Edouard Duval-Carrié, *Soucouyant #3*, 2017, mixed media, 95 inches in diameter. Image courtesy of the artist.

Edouard Duval-Carrié, *Soucouyant #4* 2017, mixed media, 96 inches in diameter. Image courtesy of the artist.

Edouard Duval-Carrié, *Purple Lace Tree*, 2013, mixed media on aluminum in artist's frame, 71 x 86 inches. Lyle O. Reitzel Gallery New York—Santo Domingo.

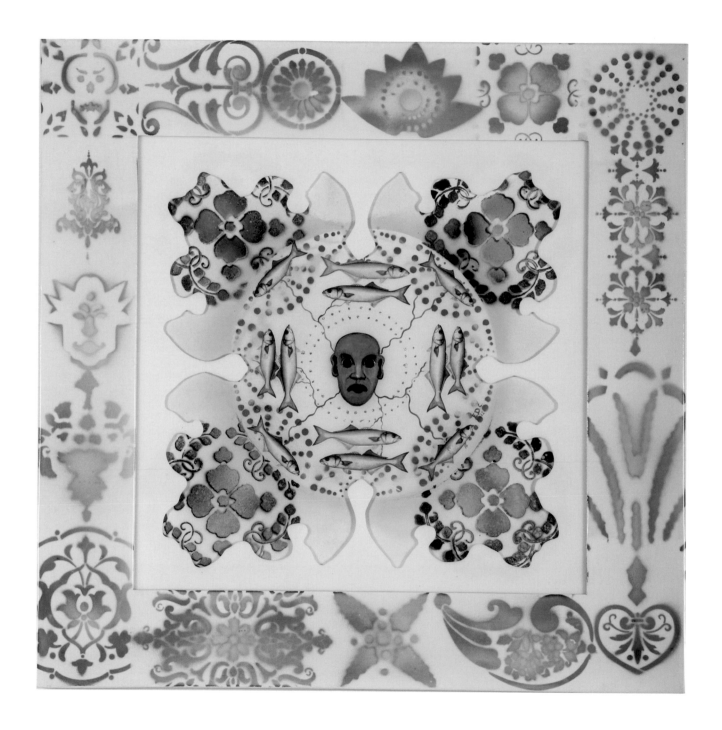

Edouard Duval-Carrié, *Delft Blue Eskimo*, 2012, mixed media on aluminum, 33 x 33 inches. Lyle O. Reitzel Gallery New York—Santo Domingo.

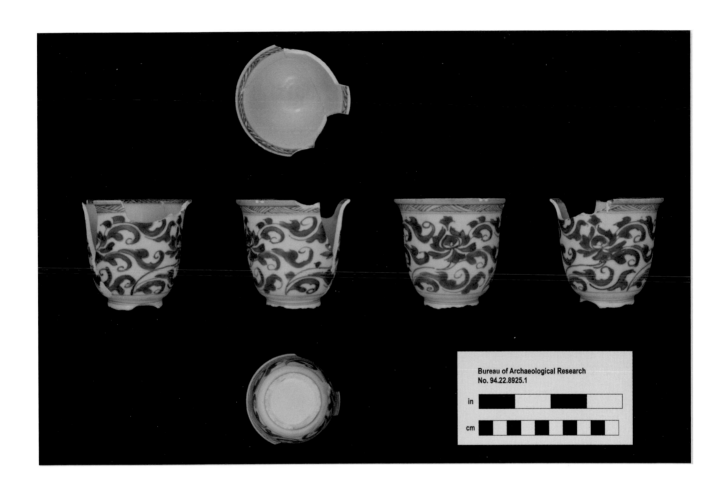

Tea cup, no date, blue and white porcelain. Image courtesy of Florida Division of Historical Resources.

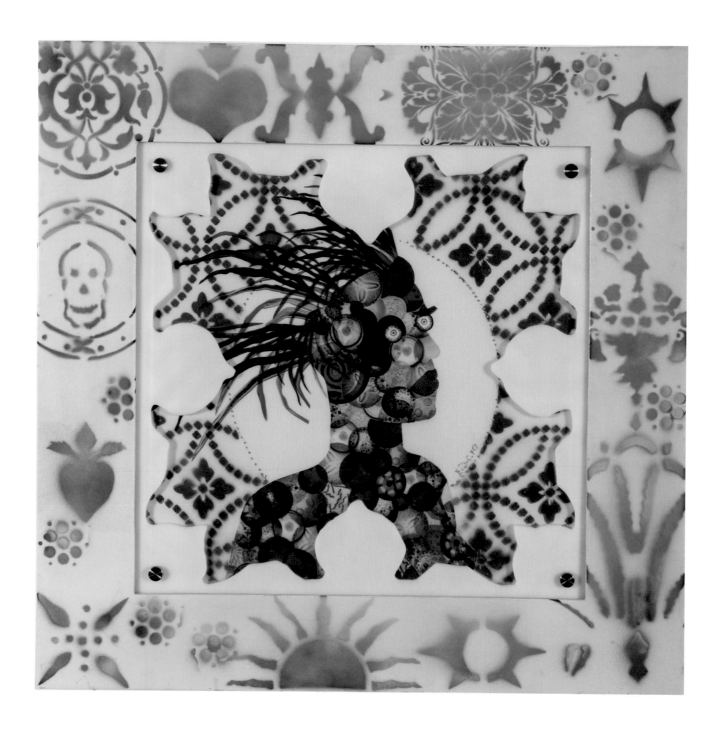

Edouard Duval-Carrié, *Delft Mutant I*, 2012, 33 x 33 inches. Lyle O. Reitzel Gallery New York—Santo Domingo.

Tombstone, strap form cross, diamond shaped center plate, iron, 6 x 7.2 inches, originally from Oakland Plantation Cemetery, Louisiana. Image courtesy of the Southeast Archaeological Center, US National Parks Service.

Edouard Duval-Carrié, *Makandal as Mosquito*, 2017, mixed media, 48 inches in diameter. Image courtesy of the artist.

THE KINGDOM OF THIS WORLD

Alejo Carpentier
The Kingdom of This World

In this engraved series, Edouard Duval-Carrié has made a number of images inspired by the novel *The Kingdom of This World* (first published in 1949) by author Alejo Carpentier (b. 1904, Lausanne, Switzerland; d. 1980, Paris, France), who grew up and studied in Havana, Cuba. The book's protagonists, Makandal and Ti Noël, both formerly enslaved laborers on Ste. Domingue, reappear throughout Duval-Carrié's series, shown at various intervals in their spiritual, political, and physical transformations. Interspersed among these scenes, the artist illustrates moments of violence that foreshadow the Revolution to come.

These fifteen engraved plates were produced on Plexiglas and then duplicated with laser technologies made available through the Facility for Arts Research at Florida State University. The myriad layers of replication and interpretation embedded in this series—from text, to image, to duplicate engraving—echo the transformative actions portrayed in Carpentier's novel. Duval-Carrié features the engraved plates, rather than the prints rendered from them, as art objects unto themselves, which have been framed and hung in the museum gallery. This series thus uniquely challenges expectations of artistic labor and the visual consumption of art and reveals these processes as mutually transformative.

Alejo Carpentier, *The Kingdom of This World*, New York: Farrar, Straus & Giroux, [1949] 1957

Edouard Duval-Carrié, *The Kingdom of This World*, 2017, etching on Plexiglas, 20 x 14 inches. Image courtesy of the artist.

"Above the summit of Le Bonnet de l'Évêque, dentelated with scaffolding, rose that second mountain—a mountain on a mountain—which was the Citadel La Ferrière. A lush growth of red fungi was mounting the flanks of the main tower with the terse smoothness of brocade, having already covered the foundations and buttresses, and was spreading polyp profiles over the ocher walls. That mass of fired brick, towering above the clouds in proportions whose perspective challenged visual habits, was honeycombed with tunnels, passageways, secret corridors, and chimneys heavy with shadows." (113)

Edouard Duval-Carrié, *L'Etal du Coiffeur*, 2017, etching on Plexiglas, 20 x 14 inches. Image courtesy of the artist.

"By an amusing coincidence, in the window of the tripe-shop next door there were calves' heads, skinned and each with a sprig of parsley across the tongue, which possessed the same waxy quality. They seemed asleep among the pickled oxtails, calf's-foot jelly, and pots of tripe à la mode de Caen. Only a wooden wall separated the two counters, and it amused Ti Noël to think that alongside the pale calves' heads, heads of white men were served on the same tablecloth. Just as fowl for a banquet are adorned with their feathers, so some experienced, macabre cook might have trimmed the heads with their best wigs." (5)

Edouard Duval-Carrié, *L'Accident à la Guildive*, 2017, etching on Plexiglas, 20 x 14 inches. Image courtesy of the artist.

"The horse, stumbling, dropped to its knees. There came a howl so piercing and so prolonged that it reached the neighboring plantations, frightening the pigeons. Macandal's left hand had been caught with the cane by the sudden tug of the rollers, which had dragged in his arm up to the shoulder." (4)

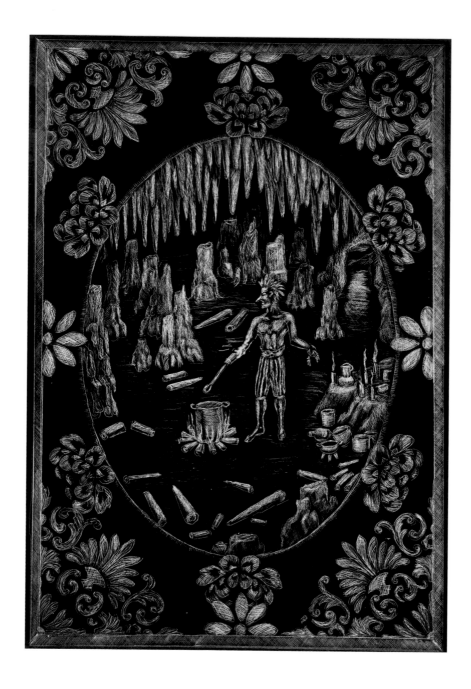

Edouard Duval-Carrié, *Le Grotte des Poisons*, 2017, etching on Plexiglas, 20 x 14 inches. Image courtesy of the artist.

"But now what interested Macandal most was the fungi. There were those which smelled of wood rot, of medicine bottles, of cellars, of sickness, pushing through the ground in the shape of ears, ox-tongues, wrinkled excrescences, covered with exudations, opening their striped parasols in damp recesses, the homes of toads that slept or watched with open eyelids." (18)

Edouard Duval-Carrié, *Metamorphose #1*, 2017, etching on Plexiglas, 20 x 14 inches. Image courtesy of the artist.

Edouard Duval-Carrié, *Metamorphose #2*, 2017, etching on Plexiglas, 20 x 14 inches. Image courtesy of the artist.

Edouard Duval-Carrié, *Metamorphose #3*, 2017, etching on Plexiglas, 20 x 14 inches. Image courtesy of the artist.

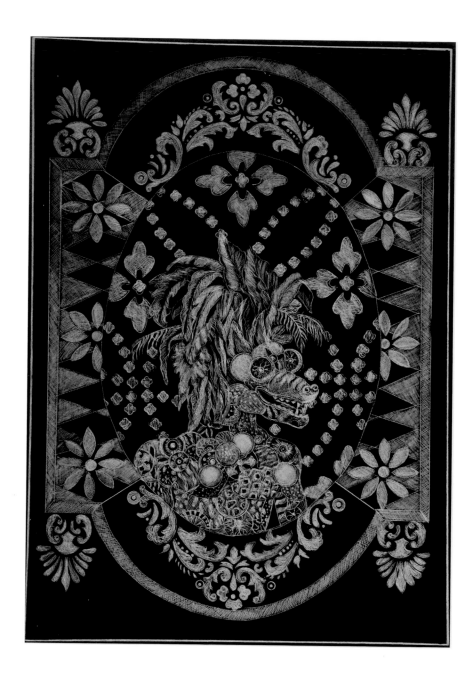

Edouard Duval-Carrié, *Metamorphose #4*, 2017, etching on Plexiglas, 20 x 14 inches. Image courtesy of the artist.

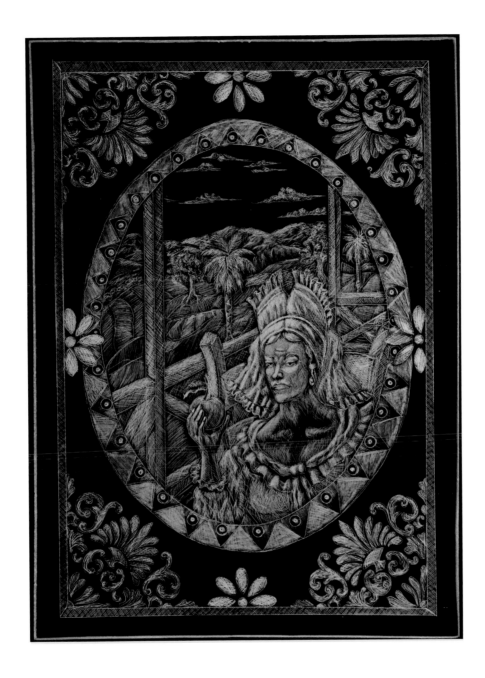

Edouard Duval-Carrié, *L'Orange de Mme Lenormand de Mezy*, 2017, etching on Plexiglas, 20 x 14 inches. Image courtesy of the artist.

"With involuntary haste to occupy the last grave left in the cemetery, Mme Lenormand de Mézy died on Whitsunday a little while after tasting a particularly tempting orange that an over obliging limb had put within her reach." (29)

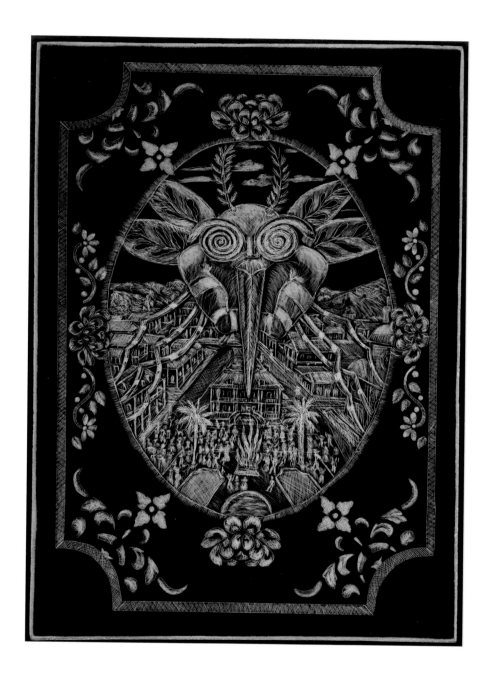

Edouard Duval-Carrié, *Makandal S'Envole*, 2017, etching on Plexiglas, 20 x 14 inches. Image courtesy of the artist.

"The bonds fell off and the body of the Negro rose in the air, flying overhead, until it plunged into the black waves of the sea of slaves. A single cry filled the square: 'Macandal saved!'" (45-46)

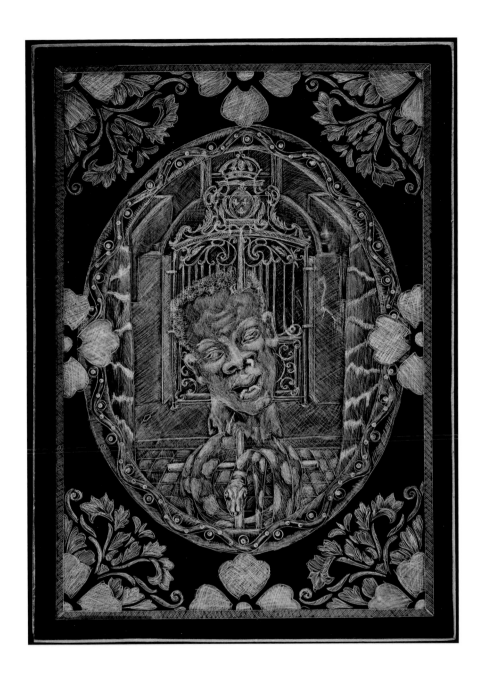

Edouard Duval-Carrié, *La Tête de Boukman*, 2017, etching on Plexiglas, 20 x 14 inches. Image courtesy of the artist.

"The horde had been defeated. The head of the Jamaican, Bouckman, green and open-mouthed, was already crawling with worms on the very spot where Macandal's flesh had come stinking ashes." (70)

Edouard Duval-Carrié, *Les Mastiffs Cubain*, 2017, etching on Plexiglas, 20 x 14 inches. Image courtesy of the artist.

"One morning the harbor of Santiago was filled with barking. Chained to each other, growling and slavering behind their muzzles, trying to bite their keepers and one another, hurling themselves at the people watching behind the grilled windows, hundreds of dogs were being driven with whips into the hold of a sailing ship." (83)

Edouard Duval-Carrié, *L'Apotheose de Makandal*, 2017, etching on Plexiglas, 20 x 14 inches.
Image courtesy of the artist.

Edouard Duval-Carrié, *Ti Noël à Sans Souci*, 2017, etching on Plexiglas, 20 x 14 inches. Image courtesy of the artist.

"Against a backdrop of mountains violet-striped by deep gorges, rose a rose-colored palace, a fortress with ogival windows, rendered almost ethereal by the high socle of its stone stairway. To one side stood long-roofed sheds that were probably workshops, barracks, stables. To the other stood a round building crowned by a cupola resting on white columns where surplice priests went in and out." (107-108)

Edouard Duval-Carrié, *La Fin de Ti Noël*, 2017, etching on Plexiglas, 20 x 14 inches. Image courtesy of the artist.

"No known goose had sung or danced the day of Ti Noël's wedding. None of those alive had seen him hatched out. He presented himself without proper family background, before geese who could trace their ancestry back four generations. In a word, he was an upstart, an intruder." (177-178)

Authors' Biographies

Anthony Bogues

Anthony Bogues is a Caribbean political theorist, intellectual historian, writer and curator and currently Director of the Center for the Study of Slavery & Justice at Brown University and the Asa Messer Professor of Humanities and Critical Theory. He is also an Honorary Research Professor at the University of Cape Town. In 2012, he was also the Distinguished Faculty Fellow, Marta Sutton Weeks Distinguished Visitor at Stanford University. He has written extensively on African and African Diaspora political theory and intellectual history. As a curator he curates and writes about Haitian Art.

Michael D. Carrasco

Michael D. Carrasco is an Associate Professor in the Department of Art History at Florida State University. He specializes in the visual culture, literature, and writing systems of the indigenous peoples of Latin America, with a specific focus on the Maya. He is the co-editor of *Pre-Columbian Foodways: Interdisciplinary Approaches to Food, Culture, and Markets in Ancient Mesoamerica* (Springer, 2010), *Parallel Worlds: Genre, Discourse, and Poetics in Contemporary, Colonial, and Classic Maya Literature* (University Press of Colorado, 2012), and *New Perspectives on Interregional Interaction in Ancient Mesoamerica* (2018). Since 1997 he has conducted regular fieldwork in Guatemala and Mexico, most recently with support from the National Endowment for the Humanities and the Consejo Nacional de Ciencia y Tecnología.

Martin Munro

Martin Munro is Eminent Scholar and Winthrop-King Professor of French and Francophone Studies in the Department of Modern Languages and Linguistics at Florida State University. A specialist in Francophone Caribbean literature and culture, he is the author of many publications including the books *Different Drummers: Rhythm and Race in the Americas* (University of California Press, 2010) and *Writing on the Fault Line: Haitian Literature and the Earthquake of 2010* (Liverpool University Press, 2014).

Paul B. Niell

Paul Niell is Associate Professor in the Department of Art History at Florida State University. He specializes in the architecture and material culture of the Caribbean with an emphasis on the Spanish-speaking islands in the colonial period. His articles have appeared in *The Art Bulletin*, the *Bulletin of Latin American Research*, and the *Colonial Latin American Review*, among others. He is author of *Urban Space as Heritage in Late Colonial Cuba: Classicism and Dissonance on the Plaza de Armas of Havana*, 1754-1828 (University of Texas Press, 2015).

Edward J. Sullivan

Edward J. Sullivan is the Helen Gould Sheppard Professor of the History of Art at the Institute of Fine Arts and the Department of Art History, New York University. He is the author of many books on modern and contemporary art of Latin America and the Caribbean, including *The Language of Objects in the Art of the Americas* (Yale University Press, 2007); *From San Juan to Paris and Back: Francisco Oller and Caribbean Art in the Era of Impressionism* (Yale University Press, 2014); and *Making the Americas Modern: Hemispheric Art, 1910-1960* (Laurence King, 2018). He is also the editor of *Nueva York: 1613–1945* (Scala Books, 2010) and *The Americas Revealed: Collecting Colonial and Modern Latin American Art in the United States* (Pennsylvania State Press, 2017). Sullivan has also served as independent curator for exhibitions in museums in the US, Latin America and Europe throughout his career.

Lesley A. Wolff

Lesley A. Wolff is an Adelaide Wilson Fellow and PhD Candidate in the Department of Art History at Florida State University and a Graduate Curatorial Fellow in American Art at the Norton Museum of Art. Her research considers the visual and sensorial landscape of foodways in modern and contemporary Mexico and the Caribbean. She has worked in various capacities for museums around the country, including as curator of the exhibition "As Cosmopolitans and Strangers: Mexican Art of the Jewish Diaspora" for the National Museum of Mexican Art. Her articles on art, food, and consumption are forthcoming from *African and Black Diaspora: An International Journal* and *Food, Culture & Society*.

Florida State University

Florida State University

John E. Thrasher, President • Sally E. McRorie, Provost & Executive Vice President for Academic Affairs • Scott A. Shamp, Interim Dean, College of Fine Arts

Museum of Fine Arts Staff

Allys Palladino-Craig, Director & Editor in Chief, MoFA Press • Jean D. Young, Deputy Director, Registrar & Publications Designer • Wayne T. Vonada, Jr., Exhibitions Preparator & Designer • Elizabeth McLendon, Archivist & Communications Coordinator • Viki D. Thompson Wylder, Curator of Education • Rachel A. Collins, Chief Operations Manager, CFA • Tom Wylder, Special Events Staff • Caitlin Mims, Art History Research Assistant • Ashton Bird, Art Department Graduate Assistant

Museum Advisory Committee

Jessica Comas, CFA Senior Development Officer • Jack Freiberg, CFA Associate Dean • Joséphine A. Garibaldi, Chair, School of Dance • David Gussak, Chair, Art Education & Interim Chair, Department of Art • Cameron Jackson, Director, School of Theatre • Adam Jolles, Chair, Art History • Allys Palladino-Craig, Director, Museum of Fine Arts • Scott A. Shamp, CFA Interim Dean • Lisa Waxman, Chair, Interior Architecture & Design

MoFA Interns & Volunteers

Annette Bohn, Volunteer Coordinator • George Bricker,Volunteer • Madison Bryant, Intern • Jasmine Caya, Intern • Victoria Deblasio, Intern • Cam Ducilon, Intern • Kathryn Floyd, Volunteer Coordinator • Anna Freeman, Intern • Justin French, Intern • George Ham, Volunteer • Dakyung Ham, Volunteer • Lexi Herrmann, Intern • Julia Kershaw, Intern • Ashton Langrick, Intern • Abigail Mann, Volunteer • Noel Mendoza, Volunteer • James Oliveros, Intern • Sarah Painter, Intern • Daniela Restrepo, Intern • Sarah Smith, Volunteer • Yi Zhu, Intern • Morgan Zoldak, Intern

Cultural Heritage Theory and Practice

Art History course taught by Dr. Michael Carrasco • Students: Nina Gonzalbez • Kaley Craig • Michelina Schulze • Haylee Glasel • Jason Mitchell • Jessica Rassau • Catherine Rucker • Courtney Robinson • Hadley Knapp • Phyllis Asztalos • Annie Booth

College of Fine Arts Gold Society

Margaret A. and Robert A. Allesee • Charles L. and Margery K. Barancik • Benjamin L. Bivins and Elece Harrison • Brenda G. Boone • Robert D. Bradbury • Terry P. and Linda Holdenor Cole • Betsy R. Coville • Sandra J. and James L. Dafoe • Margaret A. and Scott Douglass • Frank and Jo Ann Fain • Herman H. and Sharon G. Frankel • Steven and Blanche Gordon • Frank D. and Jane A. Grimmett • Nona M. Heaslip • Charles L. Huisking, III • Barbara A. Judd • Herbert E. and Maija U. Kaufman • Donald R. Kerr and Jessie J. Lovano-Kerr • George M. Kole and Judith A. Zuckerberg • Ruth B. Kreindler • Sharon Maxwell-Ferguson and Howell L. Ferguson • James C. McNeil • Jane E. and George D. Morgan • Lucie M. and Charles C. Patton • Maurice Richards and Jack Kesler • Marcia L. Rosal • Julianne R. and David J. Schulte • Alison Stone • Robert L. Ward • Peter D. Weishar and Donna G. Zelazny • Jacqueline C. and Charles L. Whited • Howard W. Kessler and Anne G. Van Meter • Segundo J. and Bobbie C. Fernandez • Edith Winston • Organizations: Barber Marketing, Inc., Ekk & Hamilton Realty, LLC and The Patterson Foundation